Natural Light
and Night
Photography

Minolta Corporation
Ramsey, New Jersey

Doubleday & Company
Garden City, New York

Photo Credits: All the photographs in this book were taken by J. and C. Child unless otherwise credited. Cover:T. Tracy; p. 3: T. Tracy; p. 4: T. Tracy.

Minolta Corporation
Marketers to the Photographic Trade

Doubleday & Company, Inc.
Distributors to the Book Trade

This book and the other books in the Modern Photo Guide Series were created and produced by Avalon Communications, Inc. and The Photographic Book Co., Inc.

Library of Congress Catalog Card Number: 81-71223
ISBN: 0-385-18156-6

Cover and Book Design: Richard Liu
Typesetting: Com Com (Haddon Craftsmen, Inc.)
Printing and Binding: W. A. Krueger Company
Paper: Warren Webflo
Separations: Spectragraphic, Inc.

Manufactured in the United States of America
10 9 8 7 6 5 4 3 2 1

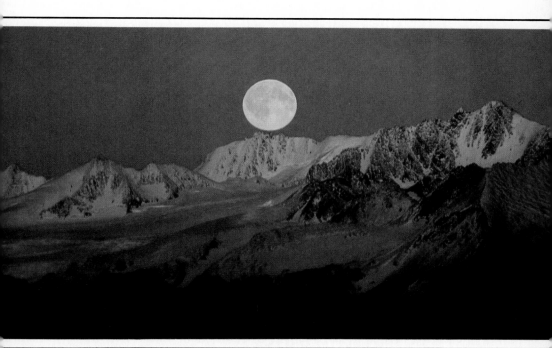

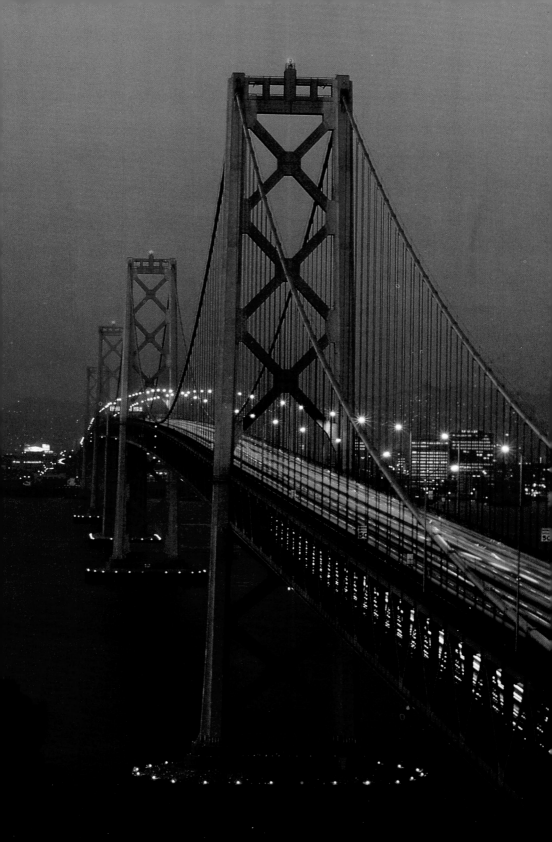

Contents

Introduction **6**

1 The Characteristics of Light **12**
Light Direction and Angle 14 ☐ Light Qualities at Night 16 ☐ Intensity and Quality of Light 18 ☐ Light and Color 20 ☐Color and Time of Day 22 ☐ Light and Form 24

2 Exposure **26**
Estimating Exposure 28 ☐ Measuring Exposure—Meters 30 ☐ Spot Meters 32 ☐ Effective Exposure 34 ☐ Interpreting Meter Readings 36

3 Photographing With Direct Sunlight **38**
Types of Lighting—Front and Side 40 ☐ Types of Lighting—Back and Top 44 ☐ High-Key and Low-Key Effects 48 ☐ Filters with Natural Light 50 ☐ Photographing Sunrise and Sunset 52

4 Natural Light **54**
Reflecting Light 56 ☐ Diffusing Light 58 ☐ Boosting Window Light 59 ☐ Fill-in Flash 60 ☐ Filters for Color Control 62

5 Soft Light and Special Films **64**
Open Shade and Mixed Light 66 ☐ Overcast and Bad Weather Lighting 68 ☐ Special Color Films 70 ☐ Making ''Wrong'' Color Right 71 ☐ High Contrast Black-and-White Films 72 ☐ Special Black-and-White Films 74

6 Night Photography: Equipment and Exposure **76**
Tripods and Unipods 79 ☐ Other Camera Supports 80 ☐ Films for Night Photography 82 ☐ Determining Exposure at Night 84 ☐ Long Exposures 86 ☐ Special Processing 88

7 Night Lights and Night Subjects **90**
Street Scenes at Night 92 ☐ Cityscapes and Buildings 94 ☐ Lighted Interiors 96 ☐ Night Sports Events 98 ☐ Carnivals, Fairs, and Amusement Parks 100 ☐ Night Flash 102 ☐ Photography by Moonlight 104

8 Special Night Effects **106**
Sky Shooting 108 ☐ Moon Pictures 110 ☐ Time, Movement, and Multiple Exposures 112 ☐ Painting with Light 114 ☐ More Ideas for Night Photography 116 ☐ Day for Night for Day 118

Index **120**

Technique Tips

Throughout the book this symbol indicates material that supplements the text and which has been set off for your special attention. You can apply the data and information in these Technique Tips immediately to get better results in your photography.

Introduction

Light is the essence of photography. Whatever the eye can see, the camera can record because of light. Whether you want to explore the wonders of the universe through a telescope-mounted camera or just to photograph a birthday party in your living room, your understanding of light will be the key to success.

When you first started taking pictures, chances are that you never gave the light around you any serious thought. You followed the aim-and-shoot approach when you were outdoors, then utilized the same technique, though with a flashcube added, when you went inside. Sometimes your pictures had harsh shadows. Other times everything seemed to be dull gray. Colors might have been vibrantly brilliant in one picture and almost monochromatic in the next. A picture of a

Light is the basic raw material of all photography. Whether you are making pictures of scenic vistas, portraits, closeups of natural phenomena, or sporting events, your photographs will be more compelling if you know how to make creative use of the natural light on your subject. Photo: M. Fairchild.

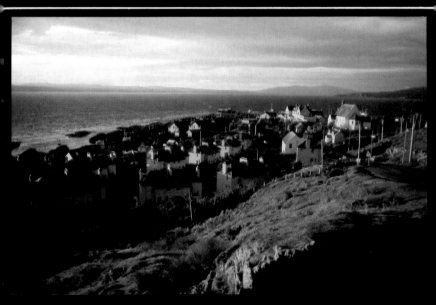

Sports photography at night sometimes involves shooting under brighter conditions than those you might encounter in the daytime. The intense lighting found in many major sports arenas will allow you to concentrate on moments of peak action, instead of worrying about long exposures. Photo: P. J. Bereswill.

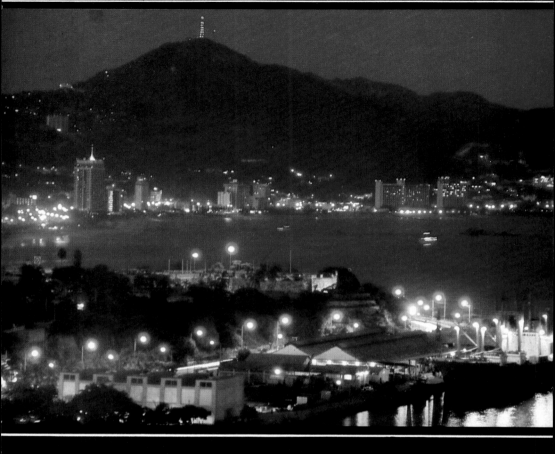

Pictures such as this are possible even if you only have a modestly priced, simple camera. This photograph works because of the nature of light at dusk, not because of the equipment used to capture the image. Photo: B. Sastre.

flower would show texture, form, and a three-dimensional life of its own when you took it in the early morning. Yet that same flower, recorded at lunchtime, resulted in a dull snapshot.

You never understood why all this was happening. You looked at your pictures and made all the usual excuses. "If I had a better camera . . ." "If I used a different film . . ." "If I hadn't been unlucky . . ." If . . . If . . . If. . . .

And then you started thinking this over. Professional photographers take beautiful pictures of a broad range of subjects every day. Sometimes they use extremely expensive equipment. Sometimes the day is perfect for the subject matter. Other times they might be using

a camera no more complex than the first one you owned, and the sky might be cloudy and heavily overcast. All the conditions might have been "wrong", yet the pictures still have a quality that makes you want to look at them over and over again. The reason had to be that the professionals knew something you did not. You also realized you could learn these secrets easily and that is why you have purchased this book.

One major reason professional photographers make consistently good pictures is that they understand both the technical and expressive functions of light. When you learn to see—and if you take advantage of what is affecting the scene you wish to record—then you will be able to record it properly. Your pictures will be as good as those of the photographers you admire. More important, learning to cope with existing light is not difficult, and this book will take you step-by-step through this process.

Natural light does not always have to come from the sun. In this industrial photograph, much of the illumination is provided by the sparks and fire, rather than by artificial illumination brought in by the photographer. Photo: A. Moldvay

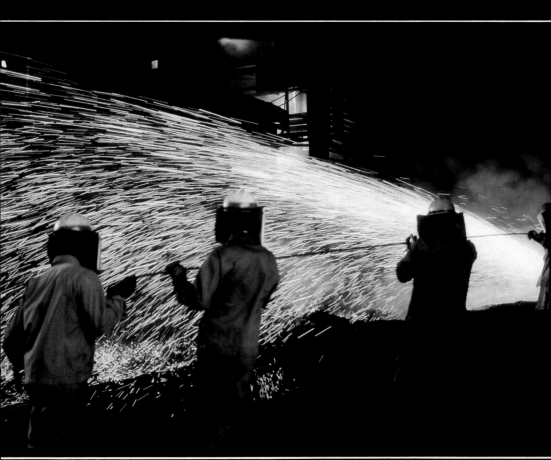

The detail, form and shape of all objects are given their character by the light reflecting from them. The light falling on a scene is as much a component part of the image as is the subject.

10

Let's try a brief exercise. Look at a flower garden or some flowers in a vase. Stand back and survey the scene. You see color and form. If the flowers are in a vase, you will also notice their arrangement.

Move closer and look at a single flower. Disregard the other flowers and concentrate on the one. You still see color and form but now, you also notice the shape of the flower, the stem, and the way it is positioned. These are things you missed when studying several flowers at once.

Now look closer. Study each petal. Look at the texture and the intertwining geometric shapes. Move in even closer and note each tiny component, which previously was viewed as a blur of color. You are studying the uniqueness of the individual plant, a uniqueness that had previously been hidden to you.

Congratulations. You have learned to perceive the world around you in a more intimate and thorough manner. You can do this exercise with any object you wish and you will begin to see the object's uniqueness. Details which were once invisible, because you did not bother to study the object carefully are now clarified.

The same situation applies to looking at light. The more you study what is all around you, the greater your understanding will be. You will instantly recognize when you might need a fill-in flash, a later hour to capture a more effective angle of the sun, a filter to enhance the coloration of the sky, or some other form of correction. Let us begin studying the different types of light, how to spot them, and how to learn how to take advantage of what you see to improve your photographs.

At times, the light falling on smooth surfaces will cause reflections. These are often distracting, but can sometimes be used to enhance your pictures.

1

The Characteristics of Light

Most photographers have only one concern about light: Is there enough of it to take the picture? Often the concern is not even expressed in terms of light. Often the question is, can I close down the lens aperture far enough for good depth of field? Or: Can I use a shutter speed fast enough to hand-hold this focal-length lens? Or perhaps: Do I need a faster film? In each case the answer really depends on how much light is falling on the subject. But the quantity—or, better, the intensity or brightness—of light is only one of its characteristics. A basic, even major concern, certainly, but only one of several.

Photographers who consistently take fine pictures of all kinds of subjects realize there are other characteristics or qualities of light that are extremely important in making a photograph. Some are physical qualities, things that can be seen directly and can be measured or evaluated objectively. Others are expressive qualities, those aspects of light that contribute to mood and emotion in a picture, or that help to bring out a sense of strength or delicacy, or other subjective qualities.

The direction from which the light comes is a major characteristic of the illumination on the subject or scene. In a large part, light direction determines how clearly both major elements and tiny details are separated from one another and how distinctly they can be seen.

The "feel" of light is a major expressive quality. Some light is hard, harsh, specific, and direct. Other light is soft, gentle, diffuse, and indirect.

The color of light is important for both expressive and technical reasons. Visible color characteristics determine whether the light seems warm or cool, and these aspects carry many kinds of emotional associations. Invisible as well as visible color characteristics determine whether the light will create true color rendition, or color changes, in the image recorded on color film.

The way a scene is illuminated determines more than any other factor what feeling your photographs convey. Here, direct sunlight has found its way through openings in the foliage, giving a dappled effect that provides a "summery" mood.

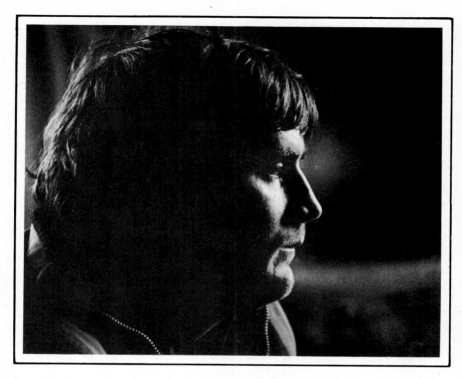

The angle at which light falls on your subject has a tremendous impact on the overall success or failure of the photograph. Here, the pensive mood of the image was greatly enhanced by placing the camera so that the light reflected almost exclusively from the subject's face, leaving the rest of the head in darkness. Photo: J. Peppler.

Light Direction and Angle

The first question to ask yourself when you decide to take a picture is "Where is the main light coming from?". Getting the answer is simple, but it is something many photographers fail to do.

Daylight. Most photographs are taken during the daylight hours, which makes the sun the source of light. But where is the sunlight coming from? Most people know that the sun is in the east just after it rises, travels to its high point in the sky around noon, then lowers into the west late in the day. If you stand in direct sunlight, your shadow shows you the light's direction and angle in relation to the earth.

For purposes of clarity, let us refer to "direction" as identifying whether the light comes from the front, the back, or the sides. This is the horizontal location of the light source.

The "angle" of light will refer to whether the light source is high, low, or at eye level. This is the vertical location of the light source.

Why is this important? The changing direction angle of the sun

will create revealing highlights and shadows on your subject. Photograph a friend facing into the sunlight in the early morning, and the illumination will be extremely flat. Your friend's face will seem to be flattened and almost featureless, like a pancake.

As the sun rises, the light and shadow areas constantly change. By about 10:30 A.M. the sun will be about 45 degrees above eye-level. Your friend's face will be more interestingly illuminated. There will be a slight shadow below the nose and perhaps under the eyebrows; the face will have a full, three-dimensional appearance.

At noon, with the sun directly overhead, the light will create shadows that are deep and probably unpleasant. The eyes may appear as deep-set black sockets, the neck will be concealed in shadow, a long shadow below the nose will cover the mouth. Every time the angle and direction of the light change, the appearance of the subject changes.

When the sun is behind a subject, its mass and overall shape are revealed, but not surface details. Because of the silhouette effect you see a single shape, not a combination of texture, color, and size.

The lower the angle of light, the more it moves across the surface of your subject, and the more clearly it delineates the details. A field of wheat, photographed in the early morning or late afternoon hours, will have every stalk and grain clearly defined. When the light is overhead, the same field looks like a carpet, nothing is clearly defined.

Light that skims the surface of a subject will also enhance colors. They will seem richer than usual, in much the same manner as the texture becomes obvious. Because of these factors, many photographers feel that the best times to take pictures outdoors occur about two hours after sunrise and two hours before sunset. In reality, the best time is determined by the effect you are seeking. By knowing what happens with light, you can plan your picture taking for the effects you wish to achieve.

For clarity, lighting angle refers to the vertical orientation of a light from a line drawn between camera and subject. Lighting direction applies to a source's horizontal orientation from the same line.

Light Qualities at Night

Outdoors, daytime light is determined by the sun. Even when the sky is hazy or overcast, or when you move into the shade, the nature of the light depends upon what has happened to the sunlight.

At night the situation is completely different. Specific techniques for night photography are covered in chapters 6 and 7; here, let's consider the characteristics of light at night. Unless you bring light of your own, such as a flash unit, you will find only two kinds of light on a scene: moonlight, or light from artificial sources that are part of the scene. Some artificial sources, like streetlights and shop windows, are fixed; others, such as automobile headlights, move through the scene. Individually and together they produce a great variety of effects.

Suppose you spot an elderly couple walking by a department-store display window. The brightest light striking your subjects is coming from a series of spotlights spilling onto the sidewalk and striking the couple from an angle of about 45 degrees.

Next the couple moves away from the window, walking towards the street corner. Now they are primarily illuminated by the light of the overhead streetlamp. As they pass, the light is harsh; it comes straight down, illuminating their clothing and the tops of their heads.

Visualize what happens. At a distance, the light strikes the couple's faces from a lower angle, so their skin seems fairly smooth. As they get closer, the relative angle is steeper; the light skims the skin surface, and every line, wrinkle, and pore begins to show. The texture of their aging faces is obvious. As they pass directly beneath the streetlamp, the light angle is so high that their hair, hats, or other clothing blocks it and their facial details disappear.

Then a third light source, the headlights of a truck, catches them from a distance at eye-level and grows in intensity as it approaches and passes by. Again, depending on the direction of the light, you will see their faces but not necessarily the texture of the skin.

Throughout this situation there are several fill light sources, and lights change function. Whichever source is brightest on the couple at any given moment is the key light, the other lights provide fill. But as they move, a fill source is now closer and becomes the key, while the original key now becomes one of the multiple fill sources. These lights will be spilling into the darker areas of the scene as well, revealing some details or, as their intensity falls off, simply some differences in tone and shape.

Obviously, artificial sources at night provide more complex, and more visually exciting, lighting than the glow of moonlight. In either case, the trick is to look carefully at what the light is doing in the lighted areas. Do not be distracted or fooled by the large areas of darkness, look where the light is and work from that.

Buildings that might appear nondescript in the daytime sometimes take on a far more interesting aspect at night, when artificial lights bathe them in various colors. The darkness of the surrounding sky can help complement the effect. Photo: J. Kalikow.

Intensity and Quality of Light

Intensity refers to the brightness of the light striking the subject. Quality refers to the harsh or soft feeling of the light. These two characteristics work together in affecting exposure and in revealing various kinds of subject qualities. Generally, hard light seems more intense than soft light, even though they are the same brightness when measured with an exposure meter. In part this is because hard light comes from a smaller, more concentrated source, which is a dazzling hot spot when you look at it directly. Soft light comes from a larger source; the same amount of light originates from a broader area, no individual point is as bright as the concentrated hard light source.

Intensity and Exposure. Your eye is more sensitive to extremes of light than photographic film and can adjust to let you see under a wide range of brightness conditions, but there is a minimum brightness you need to see. No matter how long you spend staring into darkness, your eyes cannot accumulate enough additional light to see something darker than the minimum.

Light Quality. "Hard" and "soft" are terms which describe the visual effect of specific and general light. Specific light comes from a clearly identifiable direction and creates distinct hard-edged shadows. General light comes from several directions and creates soft indistinct

Inherently contrasty subjects often look best in even lighting, such as that found on overcast days. A graphic image such as this, however, might produce interesting pictures in various kinds of light.

18

Technique Tip: Softening Light

You can learn a great deal about controlling light by making some observations and experiments. Then apply what you have observed in actually taking pictures. For example:

1. Have a subject stand close to a window with morning sunlight coming in. The light on the face will be direct and hard. Now draw a thin curtain across the window. As the light passes through, its direction is broken up, the light is diffused, and the effect on your subject is softer and more pleasing. You can do the same with any light source. Use curtain material, frosted sheets of acetate, tracing paper, an umbrella covered with a thin, light-colored fabric, or any other translucent material.

2. Stand a subject in a dark dress or shirt in direct sunlight. The light on the face seems hard, largely because of the dark, distinct shadows you can see. Have the subject change to white or light-colored clothing—or simply cover the dark clothing with a white cloth. Now light is reflected into the shadows, producing a softer, more open effect. Often you can find natural reflectors at a scene to do the same thing: the walls of a building, snow, a white fence. You can easily carry reflecting material, too, such as a white shirt, or a piece of cardboard or paper.

Whether you diffuse or reflect the light to soften it, you will find that soft light makes exposure problems much easier to solve, especially in color photography.

shadows, or even none at all. The hardness or softness of light is determined by several factors. A narrow beam of light usually seems harder than a very wide beam of light. Light is softened in its effect when it is spread to strike the subject from many different angles. For example, on a clear day the sun will send light onto your subject from a single, clearly defined direction and angle; it is a direct, hard light. However, if there is a haze in the sky or some translucent material between the light source and the subject, the light will be spread out over a wide path. It will strike your subject from many angles over a continuous, broad area. It will also be reflected from nearby ground, buildings, clothing, and other surfaces. The "overall" character of the light produces a soft, general illumination. It will reveal shape, form, and color, but not textural detail.

Light and Color

The sun is your major source of light for most daylight photography. Sunlight changes relatively little in the course of a day, but its effects on your subjects may vary widely according to the amount of atmosphere through which it must travel.

How Light Creates Color. Illumination from the sun is composed of different wavelengths of light. When they are separated, as in a rainbow or by a prism, we see the various wavelengths as separate colors. When we see the color in objects, it is because the objects reflect some of the wavelengths in the light and absorb others. The apparent white quality of direct sunlight results from a relatively equal balance of all wavelengths. If certain wavelengths dominate, we see and photograph that color. For example, early in the morning, the sun's rays are almost horizontal to the earth and they must pass through a greater amount of atmosphere than at noon. The atmosphere scatters the blue wavelengths more than it does the wavelengths of the other colors. When this scattering occurs, red and orange dominate the outdoors. A scene photographed shortly after sunrise or before sunset will have a much richer red and orange coloration, than if it were photographed at midday.

Our eyes tend to see all white light as being the same. Sources of "white" light include the sun, a car's headlight, and the bulb in your living room reading lamp. All these sources are composed of a variety of wavelengths or colors like the sun. Each type of light source has different proportions of these wavelengths, and this means that some light sources actually give off more blue or red than others. Our eyes may not perceive this, but film is not so forgiving. Each color film is sensitive to different light sources in different ways.

Color Temperature. The color composition of light can be expressed in degrees of temperature called Kelvins. The lower the Kelvin number, or *color temperature,* the more red and orange wavelengths dominate in the light. As the color temperature increases, so does the proportion of blue wavelengths.

The sun's light at noon usually has a color temperature range of 5500K to 6500K; it is rich in all wavelengths. Most electronic flash units have the same color temperature as noon sunlight. Tungsten light sources are deficient in blue wavelengths. They have lower color temperatures and produce warmer (more yellow-red) light. An ordinary household lightbulb produces, depending on its wattage, light rated from 2000K to 2900K.

Color films are designed for use with light of a specific color temperature. You must either use the correct color film for the light (daylight type film for daylight or electronic flash, tungsten type film for tungsten bulbs), or use a conversion filter. An 80A filter will let you use a daylight type film with tungsten light. An 85B filter will let you use

a tungsten film with daylight or electronic flash. The filters will provide natural color rendition; without them, a film-light mismatch produces distorted colors. Pictures taken on tungsten film by daylight will look too blue; pictures taken on daylight film by tungsten illumination will look too red-yellow.

A common problem that alters the color of sunlight is air pollution. Haze, industrial particulates, and other atmospheric factors will scatter some of the wavelengths in sunlight, and this will affect the color that is recorded on your film. Using a 1A skylight filter is the basic way to counteract this problem, but because haze and pollution factors vary widely according to location, you should make some tests in your area with various color films to see if correction is necessary.

As the sun gets lower in the sky, the color quality of daylight becomes less blue, resulting often in an overall amber or reddish hue. This scene was captured near the end of the day, giving the snow and ice a golden appearance. Photo: H. Weber.

Color and Time of Day

The color of objects and scenes outdoors varies with the time of day, because the color composition of the sunlight falling on them changes. Just before sunrise, the light is indirect. Tones tend to merge and are extremely soft. Everything has a blue cast because most of the light is coming from the open sky, which has much more blue than direct sunlight.

Then, as the sun's rays appear over the horizon, everything changes. Now the atmosphere scatters the blue wavelengths and lets the red, yellow and green wavelengths pass. Colors become warmer, with more yellow and red. Only shadowed areas, illuminated by the open sky above, show blue, and the sun is so low in angle that the shadows are long and dense.

By mid-morning, the light is closer to what we consider normal. The sun is high enough so that wavelength scattering is equal for red, green, and blue. As a result the color temperature of the light is approaching the standard noon figure of about 5500K, and object colors appear normal. The angle of the light is high enough so that objects are fully lighted, but with form-revealing shadows.

At noon the sunlight is most evenly balanced in color, but it is harshest; the shadows it creates are the shortest they will be all day, but are also the hardest to penetrate.

In the afternoon and early evening, colors change in the reverse order. As the sun gets lower, it gets warmer. More and more blue wavelengths are scattered again, shadows get longer, and the world glows red and orange once more. Finally, well after sunset, blue sky-light predominates briefly, and then color disappears as the light grows too weak for the eye to perceive color any longer.

Object colors change according to the color of the light falling on them. Foliage and grass seem greener early and late in the day because the light is blue deficient, so the amount of green reflected is more apparent. Materials that are capable of reflecting all wavelengths reveal the change in the light most clearly. White clothing and light colored skin undergo great color changes simply because of the differences in the light.

You can use these color changes expressively. By choosing the time of day you can get results as warm or as cool as you like. Or, you can overcome and neutralize the color changes by using filters to modify the color balance of the light, as explained in Chapter 3. The first step in using the color of light is learning to see it. Taking plenty of color pictures at different times of day is the easiest way to learn to see.

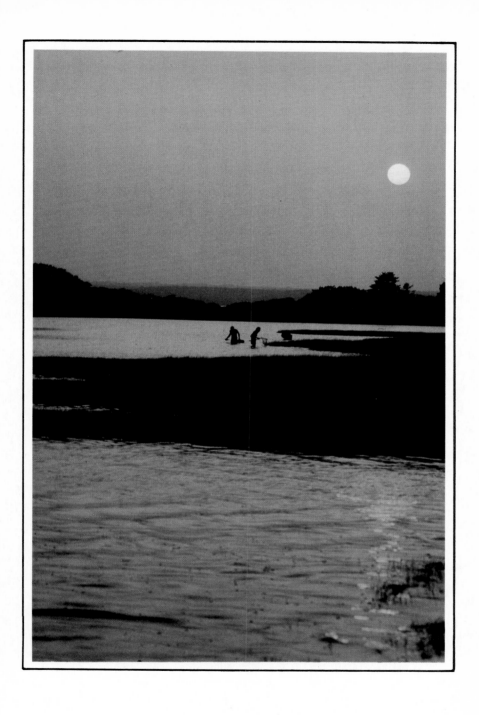

The closer the sun gets to the horizon, the redder the light becomes. Make your picture at a time of day that produces the most effective color cast on your subject.

Light and Form

Shape refers to the outer boundaries of an object; it is defined by that continuous line formed by the edges. Form is the variation of the surface or surfaces within the shape; it is the topography within the outline. Outdoors, form is revealed by the changing angle and direction of the sun throughout the day. Shadows reveal that surfaces are not flat

Shape and form in objects are determined by the amount, direction, and distribution of the light that reaches them. Early or late in the day, the sun throws contour-revealing shadows that would not appear at noon, when the sun would be higher in the sky. Photo: P. J. Bereswill.

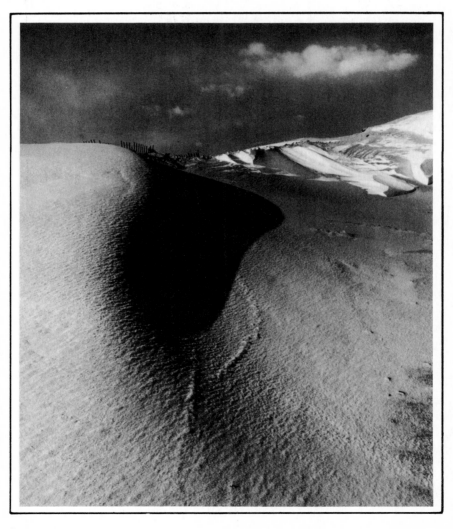

and even; they reveal the bumps, depressions, and undulations of form. Shadows change as the light direction and angle change, and so visual form changes as well.

Our eyes are trained to see volume (physical bulk) and form. When the light has an even intensity throughout a scene, we see objects clearly and recognize their relative sizes and shapes. This is usually the case outdoors. But even lighting seldom exists indoors. There we must often work with a single direct source that falls off in intensity as it spreads across the scene. Sunlight coming through a window does not illuminate a room evenly. The farther you go into the room, the weaker and more general the light becomes, and the less clearly form is revealed. (There are two major exceptions; both provide quite even lighting indoors. One is a very large window, such as a picture window, which occupies most of the wall area in which it is located. The other is overall fluorescent lighting. Both produce an overall, general illumination that softens or reduces the sense of form.)

Technique Tip: Light Direction and the Definition of Form

One of the easiest ways to see the form-defining effects of light is to place a doll on a table and use a single light to imitate the sun. You need a light that provides a directed beam—a desk lamp with a bullet-type shade, or a high-intensity light, is ideal. You will use it to gradually study all aspects of the doll.

Darken the room as much as possible, so that only your single light provides illumination. Hold the light directly above the doll, with the beam aimed straight down. Notice how the doll's hair seems to blend into the texture of the table's surface.

Now lower the light until it shines on the doll's face. Move the light around slowly, left and right, up and down, constantly changing its position. Notice how various parts of the face and head seem accented with the light in certain positions. The shape of the cheeks and nose become prominent in some cases, in others the edges of the doll's shape are emphasized. For instance, when the light is entirely behind the doll's head, the glow through the hair creates a kind of halo effect. This is identical to what happens at sunrise and sunset, when the sun is just taking full shape above the horizon.

Relate each change in the doll's appearance to the angle and direction of the light. Then, when you photograph, apply that knowledge. Position the subject in relation to the sun, or move your artifical light source, to get corresponding effects.

2

Exposure

Exposure is a major key to quality results in photography. Colors are usually most natural when recorded with proper exposure. Too much exposure weakens them. Reds, for example, become too light, almost turning pink. Other colors are similarly affected. Subtle shadings are lost. Pastel hues turn white, losing some of the color within the scene.

Slight underexposure of color slide film, by the equivalent of about half an *f*-stop, saturates the colors. Blues, greens, reds, and other hues become richer. Any greater underexposure can cause the colors to become muddy. They darken too much, and pastels become drab. Eventually, blues and blacks seem to merge, and other dark colors are lost as well. Color print (negative) film is not quite so seriously affected by exposure variations, because some correction can be made at the printing stage. Even so, the limit of exposure change before the image begins to suffer is about one *f*-stop more or less than proper exposure.

Black-and-white film has a much greater tolerance, or exposure latitude, especially for overexposure. When properly exposed, a black-and-white photograph reveals a broad range of highlight and shadow details. When too much exposure is received, not only will light areas be weak or totally washed out, but what should be rich blacks may actually become relatively uninteresting patches of gray. In addition, the grain structure of the emulsion is likely to become quite visible in the final image, breaking up fine detail, or giving a coarse-textured appearance that may be completely inappropriate to the subject.

Underexposure of black-and-white film is usually more serious a problem than overexposure. It causes white areas to be rendered gray, and dark areas to be merged into featureless black. In photographers' terms, the tonal range is shortened and dark area details are lost.

There are two basic approaches to determining exposure. You can estimate what exposure to give the film, or you can use a meter to measure the light and calculate the required exposure. Most cameras have built-in meters to help you, and many have automatic modes of operation to do the job for you.

Correct exposure is essential for a successful rendition of your subjects, especially if you use color film. Your camera's light meter or automatic exposure system will provide you with accurate exposure information in most cases. However, there are scenes which will benefit from slight underexposure, which will produce enriched, more saturated colors than those you would get by following the meter's indications exactly. In such cases, ½-stop or so less exposure than indicated by the meter is actually more "correct."

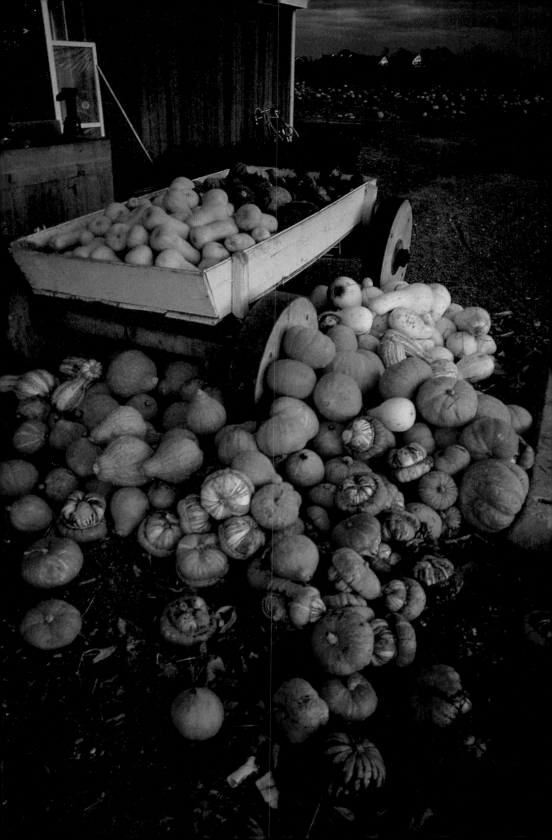

Certain subjects will not hold still long enough for you to make exposure readings of them before you shoot. Leave your camera's controls set to the shutter speed and aperture suggested in the exposure table packed with your film; this way, you will be ready to respond quickly to unexpected photographic opportunities. Photo above: C. Child; below: J. Peppler.

Estimating Exposure

The ways in which you determine exposure can vary in accuracy. The least technical method is estimation. Your ability to make correct estimates comes from your own experience. Many professional photographers rely entirely on their experience, with excellent results. Among the advantages of this method is the ability to avoid reliance on mechanical light-measuring devices, which can break down, malfunction, or be fooled into providing inaccurate information. However, experience is just that—it cannot be taught.

Tables. One method of estimating exposure is to use tables that recommend specific exposures according to film speed and certain typical lighting conditions. The instruction sheets packaged with many films contain just such tables. These tables enable you to use your eye instead of a light meter, and the resulting exposure will be extremely close to the results an exact meter reading would produce.

The tables divide the types of light into various types: Bright or hazy sunlight on light sand or snow, bright or hazy sun (with distinct shadows) on nonreflective surfaces, cloudy bright (no shadows), heavy overcast, and open shade (bright, sunny weather but with no direct light on the subject). To use the tables, set your shutter speed as indicated and read off the appropriate exposures.

The trick with using the tables is to learn not to follow them too slavishly. For example, when a table gives an exposure for bright sun, the assumption is that the subject is facing into the sun. However, this may not be the case (if you are making portraits, it *should not* be the case). If the subject is facing away from the sun, or if part of the subject is in shadow and you want to capture shadow details, you must increase the exposure.

**Technique Tip: Rule-of-Thumb for Exposure
 in Bright Sunlight**

There may be times when you find yourself without either an instruction sheet or an exposure meter. Instead of abandoning your photo plans, you can use an easy way to estimate the exposure, based on the speed rating of your film.

Your film's ISO/ASA speed is a guide to the shutter speed you should use when your lens is set at $f/16$ to photograph a subject front-lighted by bright sunlight. Simply put the number 1 over the ISO/ASA number of your film to form a fraction. For example, if your film is rated at ISO/ASA 200, a bright-sun exposure should be 1/200 sec. at $f/16$. Since your camera does not have a shutter speed of 1/200, take the next closest number—1/250 sec.

Equivalent exposures to 1/250 sec. at $f/16$ would be: 1/500 sec. at $f/11$, 1/1000 sec. at $f/8$, and 1/2000 sec. at $f/5.6$.

Use this information as a general guide. Increase your exposure by about one stop if the sun is not directly overhead, about two stops for cloudy-bright weather, and about three stops for heavy overcast or open shade. If you are near a highly reflective surface such as snow, sand, or water, decrease exposure by about one stop.

Measuring Exposure—Meters

There are several different types of exposure meters, each with a unique value. If you have a meter built into your camera, it is the one you are most likely to use. This meter is a reflected-light meter; it is also available in handheld models.

Reflected-Light Meters. A reading with a reflected-light meter is taken from the camera position, with the meter pointed at the subject. When light strikes the subject, it is reflected in different degrees depending upon the lightness and darkness of various areas of the subject. This is the light that the camera meter responds to.

Reflected-light meters are extremely useful because they deal with how bright the *subject* is, not the light falling on the subject. Especially in difficult exposure situations, it is important to measure the brightness of the subject, not the surroundings. But in order to do that accurately, you must know what area your meter covers, or "sees." Some camera meters read the entire frame area, giving equal weight to all parts of the picture. Others are weighted to give more importance to the brightness of things in the central area, or in the lower half of the frame. Still others read only the very center of the image; often this area corresponds to the central focusing circle in most single-lens reflex camera viewfinders. Check your camera or meter instructions carefully to determine exactly what the coverage pattern is. That will let you point the meter at the subject accurately, to get only the readings you need.

Your camera meter is generally accurate and will cause few problems. There are times when it can be fooled, however. For example,

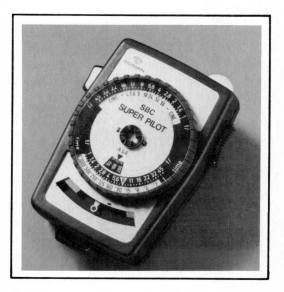

This reflected-light meter is easily converted to measure incident light by sliding the white dome at its top to the center.

suppose you photograph a brightly lit scenic area after a freshly fallen snow. The whiteness of the snow seems to intensify the light, telling a reflected light meter to expose less than is really necessary. The same happens if you have a friend pose in a white shirt and white hat. Again, the extremely reflective, bright surfaces will reflect more light than is necessary to capture all the details, and your reading will be inaccurate.

The opposite is true when your subject is very dark. Most of the light is absorbed and much less is reflected. Your meter will tell you to give more exposure than necessary, resulting in the total picture being over-exposed with subsequent loss of detail.

Incident Light Meters. An incident-light meter measures the light falling on the subject *before* it can be reflected. To use an incident-light meter, you take the reading from the subject position with the meter pointed back toward the camera position. Because the incident-light meter reads only the light striking the subject, it cannot be fooled by other lighting conditions in the vicinity, and your exposure for color film should be perfect almost every time.

Incident-light meters have white diffusers over their sensors. These frequently look like half a ping-pong ball, or a shallow inverted cone. There are also meters with ribbed screens that move in front of the sensing cell. These white covers serve to collect the light from all frontal directions. Most handheld reflected-light meters can be converted to incident-light meters by adding an attachment over the sensor. Some manufacturers offer diffusers to go over a normal camera lens for converting a built-in meter to incident-light readings.

Some exposure meters, accept a wide variety of attachments for spot metering, measuring electronic flash, determining color temperature, and other special applications.

Spot Meters

The meter in your camera is basically an averaging meter. It reads a fairly large area of the scene and averages all the light and dark portions together. It is meant to be accurate for the overall situation, but not necessarily for any particular detail. If someone is standing in the bright sun, wearing a cap with a wide brim that shadows the face, the meter will tell you how to expose so that the entire figure is accurately recorded. But because the meter averages the scene, the face will be lost in the picture. The alternative is to have a meter that measures only a small portion of the scene—a spot meter.

A spot meter has a very narrow angle of view, and tells you the proper exposure for a tiny segment of your subject. If you had a spot meter for the man standing in the sun, you would aim it at his face to determine the correct exposure for the most important area. Spot meters usually cover a one-degree angle of view. This is so small that if you are standing a few feet from your subject, the spot meter might tell you the accurate exposure for his eye, while an averaging meter would

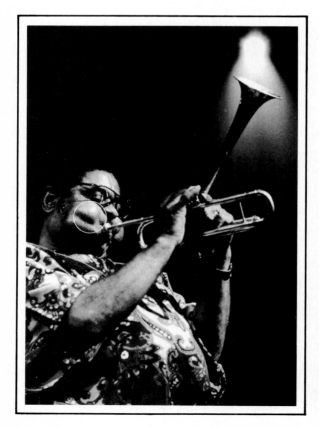

A key to using a spot meter is to identify the part of your subject— usually skin—from which you want to take an exposure reading. From a common camera-to-subject distance of 15 feet, a 1° spot meter could easily read the trumpet player's cheek only. Photo P. Bereswill.

tell you the correct exposure for his full body. Both readings could be taken from the same camera position.

A spot meter is a reflected-light meter. You can turn your camera's meter into a spot meter, if it is not designed that way, by using an extreme telephoto lens for taking your readings. This is normally not practical, but it is a technique occasionally used by sports and news photographers who have access to long lenses.

Technique Tip: Using a Camera Meter as a Spot Meter

If your camera has an overall averaging meter, or a large central-area meter (your camera instructions will tell you the meter coverage), try this trick to use it as a substitute spot meter. It works with brightly lighted subjects against a dark background, such as a spotlighted performer on an otherwise dark stage, or distant figures under a streetlight at night.

1. Frame your picture and identify in the viewfinder just what portion is being covered by the meter.

2. Estimate what proportion of the *metered* area is in darkness—one-quarter, one-half, two-thirds. The remainder is filled by the brightly lighted subject, of course.

3. If the dark portion is less than one-half the metered area, use the meter-indicated exposure.

4. If the dark portion is more than one-half the area, *decrease* the exposure by the same proportion as the dark area proportion.

For example, if the dark portion is two-thirds of the metered area, reduce normal exposure by two-thirds. This will compensate for the fact that the meter sees an excess amount of darkness and is trying to tell you how to expose for that. But you know you want to ignore the dark portions and expose the lighted subject correctly. If you used the meter-indicated exposure, you would overexpose the main subject.

5. There are various ways you can decrease the exposure. Many cameras have an under/overexposure control which lets you vary exposure up to as much as two stops in automatic operation, in other cases you can adjust the exposure by changing the film speed (ISO/ASA) setting. Or, you can switch to manual operation and change either the shutter speed or the lens *f*-stop setting the required amount.

Effective Exposure

No matter what your experience, the tables, or your exposure meter say, there is always room for error. The film in your camera has a narrow ability to record detail. Your eyes can look at a scenic area and enable you to see details in both the brightest sun and the deepest shadows; your camera's film is much more limited. You must remain aware of what you want to record and make your exposure accordingly.

(Left) Overexposure causes bright areas of a scene to appear washed-out, with little apparent detail; shadows will appear to be overly light. (Right) Less than adequate exposure will cause detail in shadow areas to disappear. Highlights will seem too dark, giving the photograph a dingy, flat appearance. (Bottom) Correct exposure will render full color and clearly defined detail in both light and dark .

Bracketing. For example, suppose you want to photograph a group of buildings in a downtown area. You are fascinated not only by the physical structures but also by the graffiti and artwork spray-painted on the side of one of the buildings. Most of the buildings are in the sun, but the painted wall is shaded. Instead of standing back and letting your meter record the average light for the whole scene, move in closer to the wall and take your reading from there. Make note of what it is, and move back to take an overall reading. Compare the two.

If the difference between the two readings is broad—more than three *f*-stops with color film—start by taking a photograph with the exposure that is best for the most important shadow detail. Then bracket the situation by closing down one *f*-stop (or doubling the shutter speed without changing the *f*-stop) for the next exposure, and another *f*-stop for a third exposure. You can also change exposure by using the under/overexposure control provided on many cameras, or by changing the film speed setting of the metering system; check your camera instructions.

In bright sun, if the most important area is in the sunlight, expose for it and let the shadow detail be lost. Then bracket by increasing exposure in one or two more shots. If details are important in both extremely bright light and in dark shadows, you will probably have to settle for two separate images.

If you are in great doubt, bracket in both directions. Give one or two f-stops more exposure and one or two stops less exposure than your first shot.

Substitute Exposure Readings. Sometimes you cannot get directly to your subject. There may be a river, or a street, or other obstacles in the way. Or you may not want to get close enough to disturb the subject. In those cases you can still use your camera meter, or a separate meter, to determine exposure accurately by reading from substitute subjects.

For example, suppose you want to photograph a couple up ahead of you, standing in a shaded doorway, as you walk by without stopping for more than an instant. It's easy enough to preset the lens focus for a convenient distance, but what about the exposure?

The easiest and most accurate approach is to spot a similar shaded location near you and take a reading from that. Set your camera accordingly.

Another approach is to remember that you always have a substitute subject with you—the palm of your hand. Hold it in the same light as the subject and taking a reading from it. If the subject is in direct sun, hold your palm toward the sun. If the subject is in shade, angle your hand so the palm is shaded. Use the resultant exposure reading directly if you are going to photograph on color slide film. Add one *f*-stop (or one shutter speed step) of exposure if you are going to use black-and-white film.

When both a bright and a dark subject appear in a scene, the exposure meter will average the reflected light and give a reading about in the middle. In a case like this, use the meter-indicated exposure without alteration.

Interpreting Meter Readings

Things do not always match the average that photographic manufacturers use as a standard. A subject that reflects much more or less than 18 percent of the light will not be recorded accurately if you rely directly on a meter reading taken from it.

Common sense is required in using, and interpreting, your meter. A meter thinks everything has average reflectance. When it sees dark skin, which reflects less than the average amount of light, it will think there is less light on everything, and will tell you to give more exposure. If you want to retain the dark, natural quality of the skin, you must know enough to reduce exposure from what the meter indicates.

In a beach or snow scene, much more than an average amount of light is reflected from the surroundings. That will make the meter think everything is bright, so it will tell you to give less exposure. You should realize that more exposure than the meter indicates will be required to record the details and colors of the main subject properly.

Bracketing exposures by giving more and less exposure than the meter indicates will make up for these meter "mistakes." But bracketing uses three times as much film, if you make just one extra exposure each way from the meter's suggestion. And with moving subjects, the pictures will be different in content as well as exposure. Use your head as well as your meter; you'll use less film and get more good pictures.

Technique Tip: Determining Exposure

Here are some fundamental techniques for determining exposure accurately.

Color Slide and Print (Negative) Films—Use the exposure indicated by any of the following:

• Reflected-light reading of the most important color in the subject; this is the skin tone in the case of people.

• Overall reflected-light reading of average scenic views and landscapes.

• Incident-light reading from the subject position, or an equivalent position in matching light.

• Reflected-light reading from an 18 percent reflectance gray card.

Black-and-White Negative Films—Adjust exposure as indicated:

• Reflected–light reading from darkest important area of subject—give two stops less exposure.

• Reflected–light reading from light colored (Caucasian) skin —give one stop less exposure.

• Reflected–light reading from dark skin—give indicated exposure.

• Overall reflected–light reading of average scenic view and landscapes—give indicated exposure.

• Incident–light reading from subject position, or equivalent —give indicated exposure

• Reflected–light reading from 18 percent reflectance gray card—give indicated exposure.

All films:

• When reading is taken so that the important portion fills the meter area, follow directions above.

• When reading includes large surrounding areas that are dark, give one–half to one stop less exposure.

• When reading includes large surrounding areas that are bright, give one–half to one stop more exposure.

Latitude. The ability of a film to record an acceptable image with more or less than perfect exposure is known as *latitude*. When you bracket exposures you are taking advantage of this latitude. With color slide film, slight underexposure is often the most effective way to record a scene because it increases color saturation and insures that bright area details are not lost.

3

Photographing with Direct Sunlight

Sunlight has always been the key to photography and painting. Long before we were able to fill the interiors of our homes with large quantities of artificial light, artists used skylights and windows to control the light striking their models.

Windows facing east or west provided a changing light that varied with the angle of the sun as the day progressed. North light, by contrast, was soft, reflected and indirect, since the direct beams of the sun occur only in the path that goes from east to west.

When photography was first developed, early portraitists such as Samuel F.B. Morse often used their knowledge of painting to plan the lighting for their photographs. In their studios they used the same lighting angles for photography as were used for painting. Thus, when you think of mastering sunlight to record your image, you are joining a group of artists and image makers who preceded the camera by many centuries.

The problem with sunlight is that, while you can go outdoors and randomly take pictures, doing so might not provide you with the proper conditions. Direct sun, open shade, reflected light, and other types of daylight must be considered if you want to photograph the best possible image. You must understand what you are encountering, how it will affect your subject, and whether or not it is the approach you wish to take.

The effect of sunlight varies, depending upon how it strikes your subject; this is influenced by the cloud cover, light angle, air pollution, time of day, and numerous other factors. You should learn to recognize different types of light, when they occur, and how you can make the most effective use of them.

The angle and direction of sunlight has a direct effect on the success of your photographs. If you encounter a scene that has possibilities but looks a little flat and lifeless, wait until later in the day—the lower angle of the sun will cause more distinct shadows and give an added sense of dimension to your subject. Photo: A. Rakoczy.

Types of Lighting—Front and Side

Frontlighting. As the word implies, frontlight is the light striking your subject head-on. In terms of sunlight, it usually refers to the effect seen during the early morning and late afternoon hours, when the light strikes your subject at a low angle.

Frontlighting gives flat results, it does not show the contours of your subject. Photography, whether portraiture or landscape work, is best done with other types of lighting. In portraiture, light that comes at an angle from slightly above your subject, and perhaps a bit to one side, makes for a more pleasing sculpting of the face. When the position of the light source is fixed as with the sun, a change in camera angle may be the solution.

The same is true with landscape photography. Frontlighting often seems to compress perspective. The only time you are likely to desire frontlighting is when you want to flatten the image. You can compress a three-dimensional urban scenic into an unusual two-dimensional effect by recording it with frontlighting and a telephoto lens, which compresses distance. For the best pictures, most of your work will be handled with the sunlight striking your subject from some other direction, not head-on.

When surface decorations are an important part of a picture—as they are in this building— it is important to keep detail obscuring shadows to a minimum. The best choice of illumination is frontlighting.

(Left) A sense of depth can be added to a front-lighted scene by placing an object in the very near foreground. When it's of secondary importance, a good idea is to let the object be a little out of focus.
(Below) With the light source only a few degrees to one side, some shadow area is visible in the picture and a feeling of texture and form appears.

Sidelighting. Sidelighting offers dramatic effects with people, buildings, still lifes, and almost everything else you want to photograph. One-half of a sidelighted subject is bright and the other side is in shadow. With a person, you can create a semi-silhouette effect, keeping your camera at an angle that allows you to capture just enough of the illuminated half to show some detail. When you photograph a building, positioning yourself at an angle where your picture captures the half-light, half-dark structure, gives a dramatic, three-dimensional effect. If you can stand back from a series of tall buildings and capture several in your picture, the images may seem to leap out at you.

Try taking cityscapes with sidelighting. Urban areas have dramatic three-dimensional qualities when approached this way.

Sidelight is actually at its best with scenic views. Distant mountain scenes cast majestic shadows. Corn fields stretch endlessly toward the horizon.

Sidelighting can be extremely effective with children at play. Is there a playground or park near your home? Watch children at play on jungle gyms and concrete structures. Move around so you see them with the light coming from various directions. Notice how sidelighting creates intricate geometric patterns from the shadows and enhances the beauty of the scene.

Low-angle sidelighting is essential to reveal the sublte contours of relatively smooth surfaces, such as those of the sand in this picture. This type of illumination will cause any subject perpendicular to the surface to be all the more obvious—note how the strong shadow cast by the flower helps it stand out againt the background. Photo: J. March.

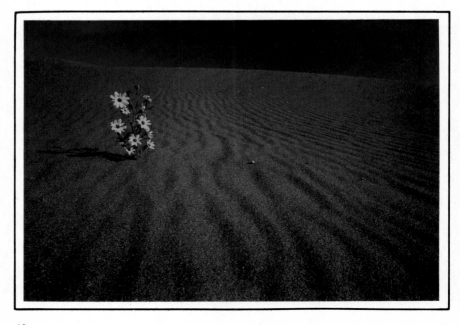

Sidelighting for portrait photography divides the subject's face down the center. One side is light and the other side is dark. Some photographers use the derogatory term "hatchet lighting" for this effect because of the sharp contrast. It is often extremely unflattering. However, when you fill in the shadow area with a reflector or a second light so that the darker side of your subject's face has some illumination, the final effect can be interesting. The added light eliminates the harsh contrast of pure sidelight.

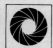

Technique Tip: Learning Exposure for Sidelighting

The major problem in taking color photographs with direct sun sidelighting is the extreme brightness range. If you expose properly for one side of the subject, you will lose details in the other side. What compromise can you make? Just what exposure between the two extremes will cope with the situation?

The best way to learn is through a series of controlled exposures. When you study the results, you will see just how much to adjust a bright-area exposure reading to get various results. Make the test exposures as follows.

1. Select a subject in direct sun and position yourself so the sun comes directly from one side. Try a bed of flowers in a garden, a person seated on the grass, a statue in the park, or something similar.

2. Take an exposure reading from the dark side of the subject. Note what it is, because you will be working toward it.

3. Take an exposure reading from the bright, sunlighted side of the subject. Make your first shot at this exposure.

4. Make a series of additional exposures, each the equivalent of one *f*-stop more exposure than the previous one. The final shot should be an exposure equivalent to the reading from the dark side of the subject. In auto-exposure operation you can easily make the series by resetting the film speed (ISO/ASA) control to half the speed of the previous exposure, for example: 125, 64, 32, etc. In manual operation, reset the lens aperture to the next lower *f*-number each time, or reset the shutter to the next lower speed.

5. Compare the processed results to see what happens in highlight and shadow rendition at each exposure step.

Types of Lighting—Back and Top

Backlighting. Backlight is the direct opposite of head-on frontlight. It is one of the most dramatic effects you can record with your camera. When handled properly, you can use it to create extremely exciting images of objects with brilliant edges and long shadows stretching toward you.

Take a look at a backlighted plant. When you stand and take a picture from a normal height, the light seems to skim across the surface, adding a dazzling reflection and deeper color. Kneel down so you are the same height as the plant, and you can position yourself so the sun seems to be coming directly through the leaves. This time you will have deep green silhouettes of the leaves.

Backlighted buildings create dramatic cityscapes. There are dark shadows, and if the sun is positioned at the appropriate angle, a kind of halo appears around the buildings. The halo effect is extremely strong when you pose a friend so that his or her back is to the low sun. The person's hair seems to glow as it almost, but not totally, blocks the brilliant light.

Exposure for backlight varies with the effect you are trying to achieve. To get a full silhouette effect, expose for the full brightness of the sunlight. If there are reflective surroundings, there may also be a trace of color or detail in the subject. If you increase the exposure one

To record this backlit scene properly, a closeup exposure reading of the bear's fur was necessary. The photographer used a long telephoto lens to make the reading, then switched to a shorter one to take the picture. Correct exposure of the fur caused a "halo" effect. Photo: K. Tweedy-Holmes.

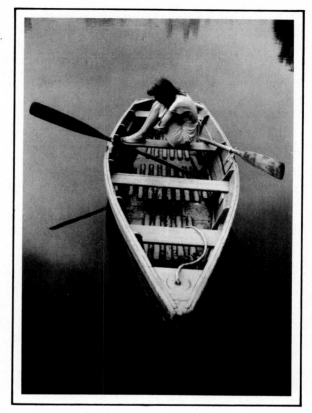

Toplight tends to lessen the three dimensional effect of certain subjects. Here the effect was further reduced by shooting down on the scene. Photo: J. Alexander.

or two *f*-stops from the full brightness reading, you will wash out the background somewhat, but let details appear in the shadowed areas facing the camera.

For a correctly exposed face with a halo effect, you must take a reading directly from your subject's face. Walk right up to the person and take the reading, so that your meter is not fooled by the strong backlight. Then move back and take the picture, using this exposure. Some automatic cameras have an exposure memory or exposure lock feature that will hold the close-up reading while you back away to your picture-taking position. Otherwise, you must use the camera in manual mode. The resulting picture will have a perfectly exposed face, but the light shining through the hair will be overexposed in a brilliant glow.

If you want to expose properly for the sunlighted surroundings *and* have full detail and color in the subject, you must add light to the shadowed side. A reflector is a simple way to do this. Position it facing the subject, just out of camera range but as close as possible, to catch the sunlight and direct it back into the dark areas. This reduces the harsh contrast between the highlight and the shadows without bringing the front light to the same level as the backlight.

Toplight, encountered at midday, sometimes results in unpleasant shadows. However, if the areas underneath the main contours of your subject are light in tone, the shadows will be lessened or eliminated. To give this scene an added sense of depth and dimension, the photographer made use of a wide-angle lens; a polarizing filter was used to darken the blue of the sky.

Toplighting. Sunlight from directly overhead produces toplighting, one of the most frustrating kinds of natural light. Most photographers try to avoid having to work with the noonday sun because of the harsh toplight it produces. In portrait situations it will turn the eyes into deep black sockets and will spread hair, eyebrow, and nose shadows down across the face.

If you must make a portrait in overhead sun, look around you to see what you can use to improve the situation. Is there a reflective surface close at hand? A sandy beach, snow on the ground, or even a light-colored sidewalk might reflect enough light into your subject's face to allow for a good photograph. If the person has white or light-colored clothing, this can also help you take a good picture. Also, look for areas where overhangs create an even shade. An awning, portico, or other protrusion can be satisfactory.

Landscapes are difficult subjects in toplight. Rolling hills and the endless depth of farmland are revealed by the shadow areas resulting from low angle sunlight. When the sun is directly overhead, everything appears flat and two-dimensional.

An advantage to toplighting with certain subjects in that they can be photographed from any direction without regard to shadow areas.

High key pictures result when the various parts of your scene are comprised mainly of whites or light tones. Slight overexposure will enhance the effect, giving an airy, gentle appearance to appropriate subjects. Photo: K. Tweedy-Holmes.

High-Key and Low-Key Effects

The terms "high key" and "low key" refer to the dominant tones, either color or shades of gray, which appear in a photograph. A high-key black-and-white image will have almost entirely white and light gray tones, with only a few accents of black. A high-key color picture, will have predominantly bright, pale colors. You can find high-key landscapes most easily in winter when the snow covers the ground and foliage, and everything appears to be dominated by the whiteness of the snow.

High-key photographs do have hints of darker tones. A small amount of a dark color adds a desirable accent to the photograph. The contrast between the overall high-key image and the small dark area adds a brilliance to such photographs that would otherwise be missing.

Low-key photographs are extremely dark in tone, though with a full tonal range. Have you ever seen a photograph of a car moving through a wooded countryside at night? The black-and-white tones are all extremely dark, except for the pure white of the car's headlights. There will be a certain amount of gray shadow details in the area illuminated by the headlights and by any overhead moonlight, but the rest of the picture will be dark. A similar low-key effect comes with adverse weather conditions in which the sky is clouded over and the light is subdued.

Technique Tip: High-Key and Low-Key Exposure

How you expose your photograph will give you considerable control over the key. For example, for a low-key landscape under a gray and overcast sky, expose for the brightest area in the picture and let everything else go naturally dark. If you expose for the darker area, you will have too many bright spots and the picture will no longer be low-key.

The reverse is necessary for a high-key photograph: you must expose for the darkest subject tone. Suppose you have a baby dressed in white, crawling on a white sheet spread across the floor and part-way up the wall. Choose a camera angle that allows you to record an endless white background. Take your exposure reading from the baby's face. This will be the darkest area of the photograph. The final result will be high-key.

It always helps to bracket your exposures when experimenting with high- and low-key lighting. Usually you will need to give slight overexposure to high-key subjects and slight underexposure to low-key subjects.

Low key photographs contain mostly dark tones. In many cases, small, light toned areas in the scene will add dimension to the picture. Photo: P. Bereswill.

Filters with Natural Light

Black-and-White. Many photographers like to alter a scene through the use of filters with black-and-white film. A yellow or red filter used with black-and-white film can improve the appearance of a skyline simply by eliminating or reducing the haze. Other filters can alter the appearance of the sky and other elements of the image.

For example, a medium yellow filter will darken a blue sky and increase its visual impact, especially if there are clouds that you wish to accentuate. A yellow-green filter may also be used to lighten the color of existing foliage.

A deep green filter greatly lightens green foliage while darkening the sky. It will also cut haze slightly. If part of the scene is red, the red will become very dark. For example, if you use a green filter to photograph a woman in a red dress sitting in a park, the bushes, tree leaves, and other greenery will become lighter and her dress and lipstick will appear almost black. Without the filter, the dress would be rendered as gray, possibly blending into the gray of the surrounding foliage.

A light red filter will reduce haze and darken skies and foliage. A deep red filter will turn a blue sky almost black. Red is lightened to the

A medium yellow filter used with black-and-white film will bring out clouds, render the sky darker, and lighten the gray tone rendition of yellow objects in the scene.

point where it appears white, and foliage appears black (a reversal of the effect of a deep green filter).

A deep red filter can be used with infrared-sensitive film. This combination results in black skies, almost white foliage, and extreme haze reduction. Other parts of the scene will record unpredictably, depending upon their infrared reflectivity.

Light blue filters will lighten blue skies and darken both reds and greens. Dark blue filters increase haze and further darken the reds and greens.

Often you can judge the effect a filter will have in black-and-white just by looking through it. Move it in and out of your line of sight, and notice which colors seem to get brighter, which seem to get darker. There is a special viewing filter, a No. 90 filter, that obliterates most color differences so you can see subject contrast as it will be recorded on panchromatic film. Try combining this with the color filter you plan to use for a close visual approximation of what you will get. Don't try to photograph through the No. 90 filter, however, just use the colored filter.

Color. Filters for black-and-white film are too strong for color photography. If you were to use them with color film, the color of the scene would be dominated by the color of the filter. A yellow filter would tint everything in the picture yellow.

Numerous filters are available to help you overcome a variety of photographic problems. This pair of photographs shows how useful a polarizing filter can be in reducing reflections. Polarizing filters will lessen or eliminate reflections in water, glass, and other non-metallic surfaces.

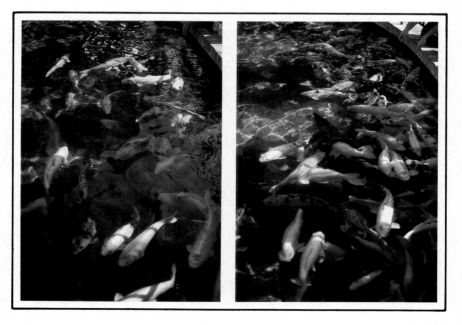

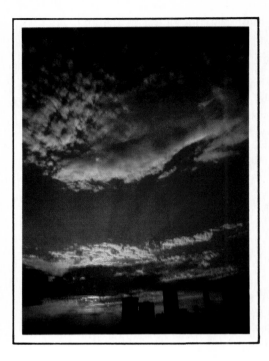

Clouds can often be more dramatically recorded at or near sunset than they can earlier in the day. The clouds at sunset may take on a dark, moody appearance, while the area around the setting sun remains golden.

Photographing Sunrise and Sunset

Sunrises and sunsets are among the most dramatic natural lighting occurrences. The colors constantly change as the sky is brilliantly lighted in an array of reds, oranges, purples, and golds. When used as a backdrop for buildings, mountains, seascapes, and people, it adds a dimension impossible to duplicate at any other time of day.

Most night architectural photographs are best made no more than 10 minutes before sunset. Many photographers like to take dramatic pictures of churches, museums, and other interesting buildings at this time, especially when on vacation. The setting sun enhances the unusual color of the scene, while leaving enough light in the sky to provide a strong outline of the building.

Take your meter reading from the brightest part of the sky but do not aim directly at the sun. At sunset, the sun will be slightly overexposed when you photograph according to that reading. However, the clouds and sky will maintain their rich color. Usually the best exposure is from a half to one full *f*-stop less than the meter reading.

Bracket your sunrise and sunset pictures by the equivalent of two full *f*-stops in each direction. If the camera's meter reads *f*/8 set your lens accordingly, then immediately take pictures at *f*/4, *f*/5.6, *f*/11, and *f*/16, all with the same shutter speed. Or, use a single *f*-stop and change shutter speeds. When using slide film, some photographers

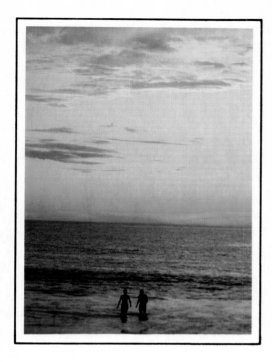

In open scenes like this, photographing at or near sunset will render people in front of your camera as silhouettes. Base your exposure on the bright areas of the scene if you want this effect; otherwise, you might get recognizable detail in the people, but the surrounding area will have a washed-out appearance.

prefer to bracket by half-stops, which allow for more subtle changes. This bracketing will give you an excellent assortment of images.

Constantly check your camera's exposure meter when photographing the sky at these times. The light changes rapidly. It will be increasing at sunrise and falling off at sunset, often changing significantly by the time you have finished bracketing from your first exposure. This is the time to plan on using a greater-than-normal quantity of film.

There may be an intense afterglow in the sky immediately after the sunset. To capture this effect, take the last exposure reading you used before full sunset, then open your lens another two to three *f*-stops, or change your shutter speed an equivalent amount. In general terms, a photograph of the afterglow about ten minutes past sunset can be made on ISO/ASA 400 film at about 1/60 sec. at f/5.6. Use that just as a starting point.

Because the light fades quickly at sunset, you will have to increase exposure with almost every shot. That means a tripod is essential, in order to have steady pictures at slower and slower shutter speeds. Start out with the camera on the tripod; you will lose too much time trying to set it up in the middle of sunset shooting.

If you are taking sunset cityscapes in winter, skyline and other details at a distance from the camera will not be brightened by snow on the ground. Although the snow does reflect the setting sunlight, it will not be enough to change your exposure. This situation is different from photographing snow scenes earlier in the afternoon.

4

Natural Light

The one problem with sunlight is that you, as the photographer, can do little to control it. It is easy to learn when the sun will be at various angles throughout the day. Unfortunately, you cannot always be out taking photographs when the sun is at its best angle for your subject. Landscapes and other panoramic scenes have to be photographed as you find them. If the setting is not right for the angle and direction of the sun, you must either wait for the right time, return at a later date, or miss the photograph completely.

In some cases you can control the subject in order to take advantage of the uncontrollable light. You often can have a person change position, for instance, or can move various objects. But even if this is not possible, all is not lost. There are a number of ways you can modify and supplement natural light to bring a picture under your control; you do not have to be a slave to the existing light.

One technique is to take some of the natural light and redirect it onto the parts of the subject that need to be brighter. This is an easy approach because it requires nothing more than a reflector, which you can improvise quite simply.

Another technique is to diffuse the light in order to spread it out over a larger area, or to soften its quality. You can add light to supplement the natural illumination. Electronic flash units are most commonly used for this purpose because they match sunlight in color balance. You can also modify the light by using filters and other devices in front of the camera lens.

All of these approaches can be used for photographs of single subjects, medium and close views, and close-ups of details. For large scale subjects such as scenic views, you are pretty well limited to using filters and related devices—you can hardly use a flash unit to lighten the shadows of a landscape! But whatever your subject, there is always something you can do to improve the situation. The information in this chapter explains how to use these techniques to get things more under your control.

Reflectors and/or portable electronic flash units are often used to "fill in" areas of a scene where unwanted shadows would otherwise appear. Here, a large white reflector was used to throw added light onto the subject's face, eliminating the shadows that the hat brim would have caused around her eyes. Photo: P. J. Bereswill.

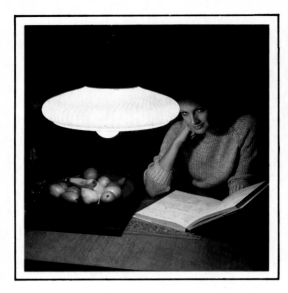

For this informal portrait, the photographer took advantage of a large, diffuse light source and the reflective properties of his subject's book. The white pages helped to "fill in" the shadows on the sitter's face. Reflectors used in color photography of this sort should be white, to avoid throwing unwanted colors onto the subject's skin. Photo: J. Alexander.

Reflecting Light

A reflector is any opaque material that "bounces" light off its surface to redirect the illumination. A reflector for color photography must be neutral in order not to add a color cast to the picture. Most artificial reflectors are white or silver, but a special device is not always necessary—there are natural reflectors in almost all photographic situations.

Natural Reflectors. Natural reflectors include white clothing, an open book or magazine, a sheet of newspaper, light colored walls, a white tabletop, a light colored automobile—anything suitable at the scene. Often you can include a natural reflector such as a magazine or a white towel in the picture. In other cases you will have to maneuver your subject into position near an immovable natural reflector, or one that would not be appropriate in the picture.

Whatever the case, keep your eye out for these very helpful items in the locale where you want to shoot. You can use reflected light to illuminate shadows, or even as a much softer main light than direct sun. Remember however that colored surfaces will color your photograph; a red brick wall will throw reddish light on the subject, a green hedge will reflect green. If you use such natural reflectors, be sure that they produce an effect you want.

Umbrella Reflectors. The umbrella reflector is a popular lighting accessory. Highly reflective material is mounted on a frame that opens to a typical umbrella shape, or almost flat. The flat shape provides a larger surface and better control of natural light.

Technique Tip: Making Reflectors

You can make reflectors cheaply and easily, and get something that is exactly what you want. The simplest reflector is simply a flat sheet of white cardboard, such as poster board, or plywood painted white. But you will have a more versatile device if you cut the board in half and hinge the halves together. This will let you "book" it, so it will stand without additional support. It also will let you angle the sides to direct the reflected light more precisely than a flat board allows. And it will let you fold the reflector in half for easier carrying.

To make a book reflector, get a 50 × 75 cm (20″ × 30″) piece of illustration board at an art store, or a piece of 1/4″ thick plywood. Cut the board in half, then make hinges with strong cloth-backed tape such as duct tape.

You can make a somewhat more efficient reflector out of stiff corrugated cardboard, or plywood, covered with reflective material on one side, and white on the other. For the reflective side use heavy duty kitchen aluminum foil. Tape the edges with silver duct tape, and staple the center in several spots. To avoid hot spots or glare, crumple the foil carefully, then smooth it out over the board. This will leave ridges and bumps in a randomly uneven surface that will reflect the light all in the same general direction, but will not form a direct beam. Use paint or white cloth for the white side of the reflector.

The large white card you see here is used to "fill in" the shadow areas of the model's features. Without it, there would be little detail in the darker portions of the sitter's face, causing too much contrast between them and the areas lit by direct sunlight.

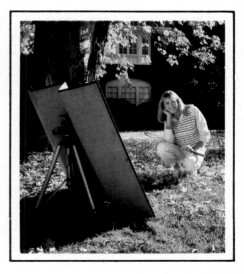

Diffusing Light

Direct light goes from the source to your subject without interruption. It can be extremely harsh, although this depends in part upon how large the source is in comparison to the area the light covers. A narrow beam, such as that produced by a spotlight, is as harsh as direct sunlight because it is used relatively quite close to the subject.

The sun's light may be softened at times by dispersion as it passes through the atmosphere. However, it is only when light is either indirect or is broken up along its path that it is truly softened or diffused.

A reflector produces diffuse light; the more matte its surface, the more the light is diffused. This is probably the easiest way to work with sunlight. Otherwise it is hard to diffuse the direct sun. One way is to place translucent material between the sun and your subject. For example, you can stretch one or more layers of cheesecloth or other thin, white material on a large frame. (Make a frame of wood, or buy one at an art supply store.) Angle the cloth-covered frame so the sunlight passes through it before striking your subject. The density of the cloth, or the number of layers, controls how much the light will be diffused.

Bothersome reflections on metallic objects can often be reduced to a manageable level by placing some diffusing material just outside of the picture area, between the subject and the light source. In this instance, the photographer used a piece of white cloth to diffuse, or scatter, the direct sunlight falling on the fountain.

Boosting Window Light

All the techniques suitable for outdoor light control can be used inside when photographing by window light. Reflectors, fill-in flash (see the next page), and similar methods are effective in both situations.

A reflector usually must be placed in the direct line of the sunlight that has missed the subject, angled so it throws the light back into the shadows.

You can also boost window light with extremely diffuse fill light created by reflecting flash or tungsten illumination from the ceiling or an opposite wall. Experiment a bit. If you use flash, set off the unit several times without taking a picture and watch the way the light falls. When you see an effective angle that does not override the sunlight, take the photograph.

The picture on the top was made with direct light. The one on the bottom has a reflector added to soften the shadow on the subject's face.

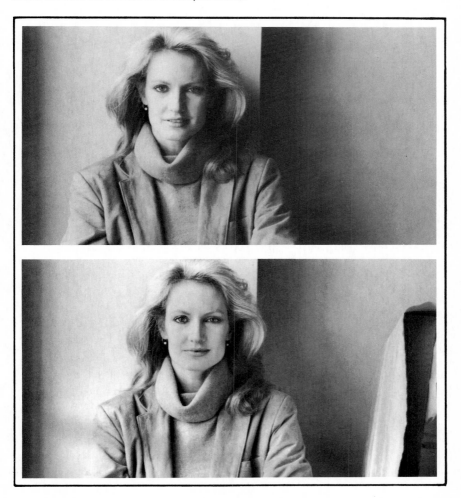

Fill-in Flash

Fill-in flash is an effective way to add light outdoors. It reduces the darkness of deep shadows cast by harsh sunlight, thereby reducing overall contrast and adding visible detail in the dark areas of the picture.

Because fill-in flash is meant to supplement the existing light, it is important that it not be so bright that it becomes the primary light on the subject. To get the proper effect, you must first determine proper exposure for the existing light, then adjust your flash so it will be equal to or less than that. To do this, you must work backward from the way you would normally figure flash exposure.

Technique Tip: Fill-in Flash Exposure

1. The sun is at a 45-degree front angle. You want to fill in the shadows with light that is one stop less bright, so as to preserve some modeling on the subject.

2. Meter the subject for proper sunlight exposure at the flash-sync shutter speed. Say the reading is $f/16$ at 1/60 sec. Set the camera and lens for this exposure.

3. To figure the manual flash data at a one-stop difference, use $f/11$. The flash unit has a guide number of 66 (for distances in feet) with your film. Divide that by $f/11 = 6$ feet. Set the flash 6 feet from the subject, no matter what your camera distance will be (so long as the flash is not in the picture).

Note: The equivalent guide number for distances in meters would be 20, so the answer would be 1.8 meters ($20 \div 11 = 1.8$). Use these factors to convert guide numbers:

GN (feet) \times 0.3 = GN (meters)
GN (meters) \times 3.3 = GN (feet)

4. For auto flash operation, see if the camera-to-subject distance is in the range covered by the $f/11$ setting of the unit. If it is, proceed with the flash set for automatic operation. If it is not, set the flash for manual operation and follow step 3, above.

The backlighted subject above was photographed by natural light only. Below, the photographer has added fill light to eliminate the shadow .

Filters for Color Control

In Chapter 3 we discussed some ways to use filters to control results in outdoor photography. Filters can be used for other kinds of control, and for special effects. The following information is a general, basic introduction to filters and specialized attachments you may find useful in various situations. For more detailed information see the companion book in this series, *How To Use Filters*.

Color Conversion Filters. You may have an indoor (tungsten type) color film in your camera and want to take pictures by the sunlight coming in the window, or you may want to use it outdoors. Because this film is meant to compensate for the lack of blue wavelengths in tungsten light, it will overemphasize the ample blue content of sunlight. To avoid overly blue results, you can use an 85B conversion filter over the lens; it will adjust the light to give much more natural colors in your pictures. (Note: One tungsten type color film, Kodachrome 40, requires a No. 85 filter for use with sunlight; all other tungsten type films require a No. 85B filter. These filters also are usable with electronic flash.)

There are other conversion filters which let you use daylight type films with tungsten light sources of various color temperatures. An 80A filter is suitable for converting light from household tungsten bulbs and 3200K photolamps to daylight color balance. An 80B filter is best with photofloods and other 3400K light sources.

Sometimes an 85B filter is not enough to correctly balance tungsten type film with electronic flash. The result will be an overall blue cast (left). To further correct a picture's color when this happens, try adding an 81A in combination with the original filter (right).

Light Balancing Filters. These filters provide slight changes in the color recorded by your film; they are very useful for outdoor photographs. The 81 series consists of warming filters. These add a hint of red to open shade or overcast situations in which the light might record a little too blue.

Technique Tip: Understanding Color Temperature and Color Balance

Various materials glow with radiated light when heated above a certain temperature; as the temperature rises beyond that point, the visible color of the light changes. The color or wavelength composition of light can be specified by an equivalent *color temperature.* This is the temperature to which a standard material (called a black body) must be heated to give off light of a matching color composition. The temperature is measured on the absolute, or Kelvin scale.

Color film emulsions are *balanced* to give accurate color rendition with light of a specific color temperature. When light of a different color temperature is used, a filter is required to adjust the light color composition to the color balance of the film, if natural looking results are desired. There are three kinds of color film emulsion color balance: Daylight, Tungsten (Type B), and Type A. The color temperature of various light sources, and the corresponding color film, is as follows.

LIGHT SOURCE	COLOR TEMPERATURE*	MATCHING FILM TYPE
Open blue sky	12000–18000K	
Midday direct sun; Electronic flash	5500–6000K	Daylight
Photoflood, 500-watt	3400K	Type A**
Photolamp, 500-watt	3200K	Tungsten (Type B)
Household tungsten bulbs	2650–3000K	

*Fluorescent bulbs cannot be rated in terms of color temperature.
**There is only one Type A still color film, Kodachrome 40.

5

Soft Light and Special Films

If you examine color advertisements, glamour pictures, and portraits in magazines, books, and catalogs, you will see that soft light predominates. In outdoor scenes, seldom does direct sun hit the front of subjects in these photographs. There is a good reason for this: Soft light creates better color pictures. It enhances subject colors. It flatters the smooth texture and delicate coloring of skin. It makes things look rich without glare and shadows. This wonderful kind of light is available naturally, almost all the time. It occurs in the shade and on overcast days.

Many photographers are frustrated by overcast days and open shade. Scenics seem to lack the three-dimensional quality which occurs when there is the contrast of sun and shadows. Blue is increased and may present a problem with color films.

One advantage of open shade and overcast is the fact that the light is more consistent than with bright sun. You can take an exposure reading with your camera and know that you will not have to check again for some time.

Fortunately, there are many interesting effects you can obtain with such even illumination. When you consider the number of times you may encounter conditions like this, it is reassuring to know that you can actually turn the day into an adventure you might never have considered.

Another factor in getting special quality in your pictures is your choice of film. Ordinary color films render the same subject somewhat differently because different dye sets are used in their manufacture. One film may favor reds slightly, another blues, and a third browns or greens. In addition, the contrast of films is different according to their speed. In general, contrast decreases as film speed increases.

Beyond that, there are several specialized films—color and black-and-white—which may produce effects you will find expressive or exciting.

The soft, even quality of the light in open shade is excellent for close range photographs of people because it does not produce harsh contrasts. If the subject is dark, a reflector or a small flash unit—as here—can be used. That will also help eliminate tinges of blue on the portions of the subject facing the camera. Another way to counteract the bluishness common in open shade is to use a skylight filter. Photo: B. Krist.

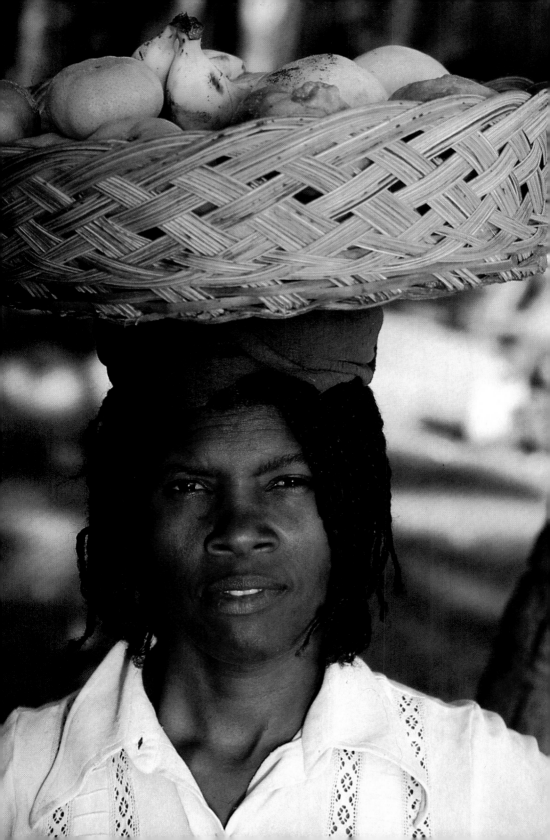

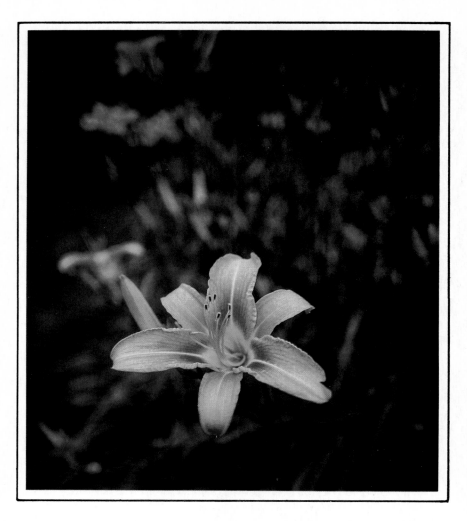

Taking pictures in the open shade with low speed film will generally require that the lens be set at a wide aperture. This will result in pictures with very shallow depth-of-field, as shown here.

Open Shade and Mixed Light

There was a time when the standard rule for photographing people in sunlight was to position them so that the sun came over the photographer's shoulder. This resulted in plenty of even light on the subject, but light that was unbearably bright. Millions of family photographs were taken showing mother, father, and all the children valiantly squinting into the harsh light. Their eyes are strained and they obviously want to be somewhere—anywhere—else.

Most amateurs followed the over-the-shoulder rule because they thought that the sun was their master. At a time when a "fast" film had a speed equivalent to about ISO/ASA 16, that may have been the case. But with today's faster films, you are much more in control; you can get excellent color pictures without direct sun.

Open Shade. Take a look at someone standing in a shaded location, one that is lighted by the open sky above, or light reflected from the surroundings, but not by direct sunlight. That is *open shade*. The light is not harsh, but it is bright and even. The person can look into your camera without eyestrain.

Sometimes open shade is created by a group of sidelighted buildings. For example, suppose you are in a downtown area where there is a row of high buildings. The first building is hit by blindingly bright morning sun on its east side. The west side of the building is in the shade, the next building is illuminated by the sun on its east side, and so on. If you place your subject between two buildings, against the shaded west wall of one, the light will be soft and even because of the open skylight plus the light reflected from the east wall of the next building. The light bounced from the neighboring wall fills in the shaded area where your subject is standing. This is naturally occurring fill light, similar in effect to what professional photographers try to duplicate in the studio with reflectors and diffusers.

Open shade occurs in parks and the countryside as well as in cities. It is found on a sunny day wherever an area is lighted by the open blue sky, but not by direct sunlight. The light is soft and even, so an exposure reading for the scene or the main subject can be used without adjustment. Usually, a skylight filter will improve results by counteracting the excess blue from the open sky light.

Mixed Light and Shade. If you try to find open shade beneath a tree on a bright day, you may discover instead a patchwork of light caused by the sun filtering through gaps in the branches and leaves. It is a spotty, camouflaging pattern that breaks up shapes, hides features, and is generally visually confusing.

One answer is to overcome the patchwork of shadows with fill-in flash, discussed in Chapter 4; another possibility is to use a reflector. However, it is more interesting to exploit the pattern for its own qualities. Look for spotlighted close-up details. Look for shadow patterns on the ground. Look up—the bright light coming through the trees creates a backlighted pattern of branches with glowing, translucent leaves. Look for the abstract effects. See what happens to those patches of light through a star filter. Look to see how things change as you vary the lens aperture. Mixed light and shade is not a visual problem, it's an interesting subject. Just look; you'll see.

Overcast and Bad Weather Lighting

The light on those days when the direct sun is obscured offers fine opportunities for color photography; it has much less potential for black-and-white. Overcast may range from a thin, haze-like condition in which the entire sky becomes a bright, general light source, to a heavy lead-gray sky from which there is hardly more than the equivalent of early-evening light. Stormy days with rolling clouds, possible patches or beams of sunshine, rain, snow, or lightning, are far more dramatic—in fact, the weather itself may become the subject of your pictures.

Overcast. You may feel frustrated when you look at a scene and find that the light is flat, shadows are non-existent, and the three-dimensional effect of bright sun light has disappeared. But look again. Do you see a cobweb hanging from a tree limb? Move in close with your camera and notice how it seems to stand out brilliantly against the darker surroundings. Such a picture is even more interesting in the early morning hours when moisture is heavy in the air.

A setting sun can be beautiful on an overcast day if some of the clouds have parted and there is an occasional patch of clear sky. That tiny patch might have a rich blue or golden color, in magnificent contrast to the grays and blacks of the remaining sky. Bracket your exposures under such circumstances, try for the best range of colors to enhance the drama.

Rainy or foggy days are often thought of by beginners as bad days for photography; but bad weather can often provide excellent picturemaking opportunities, especially if you use color films.

Rain and Fog. Rain can be a special blessing on an overcast day. Puddles and wet pavements provide color abstracts when they reflect neon signs, window lights, and similar sources of illumination. These reflections exist in sunlight as well, but the sun dominates them. An overcast day often results in colored patterns of great richness.

Fog can create mysterious effects, or can give new perspective to a scene. Any object close to your lens can usually be recorded with full detail. However, objects farther away rapidly fade from view in the fog. A close-up of a friend coming across a yard can be quite dramatic. You can isolate sections of a landscape that would be overshadowed by the surroundings on days with more sunlight.

Technique Tip: Protecting Your Camera

In bad weather you must protect your equipment from rain, snow, wind-driven dust or dirt, and other problems. Similar protection may be needed at the shore, or when photographing from a boat.

1. Carry your camera on a neck strap, under a weather-proof coat.

2. In cold weather, keep the camera close to your body as much as possible to keep batteries and lubricants in workable condition. Carry extra batteries in a warm inside pocket.

3. Protect the lens from spray, wind, and dirt with a skylight or UV filter; they are easier to clean, and cheaper to replace if damaged, than a lens element.

4. Slip a plastic bag over the camera, mouth downward so you can reach up from underneath to get at the controls. Trying to work the controls through the plastic may simply tear it. Let the lens protrude through a slit in one side; fasten the slit around the lens with tape or a rubber band if necessary.

6. Shoot from protected places whenever possible: doorways; inside a car with the window rolled down; under an umbrella held by a friend, or pressed to your body by your upper arm.

7. In cold weather, move camera controls and the film advance slowly. Brittle film can tear, or static flashes may cause stray exposures on the emulsion.

8. When coming in from the cold, leave your equipment to warm up gradually in a cool place. The moist, warm air in a heated room can cause condensation outside and inside cold cameras and lenses.

Special Color Films

When you want special effects in your daylight slides, certain specialized films will give results impossible to achieve by using filters or accessories.

Infrared Color Film. Ordinary color films respond to red, green, and blue wavelengths. Kodak Ektachrome Infrared Film responds to red, green, and infrared wavelengths, producing a modified or false color rendition of objects. Use a No. 12 deep yellow filter in daylight, and set your meter or camera for a film speed of ISO/ASA 100.

Duplicating Films. Special low-contrast color films are made for duplicating slides without loss of shadow or highlight detail in the copy. You can take advantage of the low contrast characteristics of these films to photograph high contrast subjects in bright sunlight—subjects with a brightness range well beyond the range of ordinary color films. Kodak Ektachrome Slide Duplicating Film 5071 is balanced for tungsten light, but you can use it in sunlight with an 85B filter; try a film speed rating of 16 as a start. Kodak Ektachrome SE Duplicating Film SO-366 is balanced for electronic flash, so you can use it in daylight with no filter, at a trial film speed of 32.

Micrographic Film. For good contrast in flat lighting conditions, or increased contrast in sunlight, try a film designed for taking slides through a microscope. Kodak Photomicrography Color Film 2483 has high contrast, very high resolution (fine-detail rendition), and good color saturation. It is balanced for daylight. Try a film speed of 16, with a medium green color compensating filter (CC20G).

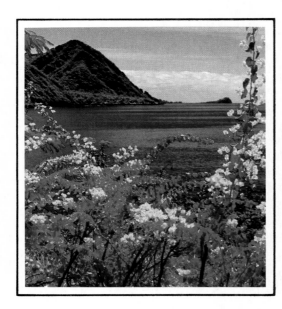

The strange colors of this scene are produced by infrared-sensitive color film. A deep yellow filter was used to further enhance the "false color" effect this kind of film provides. Your light meter is not designed to give accurate readings for infrared radiation —bracket your exposures widely, and keep notes for future reference. Photo: H. Weber.

Making "Wrong" Color Right

When a color film is used with light for which it is not balanced, subject colors are shifted and changed in the final image. While this color rendition may be technically wrong, it often is expressively and emotionally right for the kind of feeling you want in a picture. A tungsten type film used in daylight will produce blue color casts, and a lack of red; this may be very appropriate for a snow scene, or a romantic couple at twilight. A daylight color film will give very warm orange-red tones to a fireplace or campfire scene. If you use it indoors with tungsten fill light, the side of the subject lighted by sunlight through a window will be natural in color, while the fill-lighted side will be richly warm in tone. To get these effects, simply rate the films at their normal speeds and do not use a conversion filter.

Many films respond to color differently from normal at exposures longer than 1/10 sec. Notice the slight magenta cast on the church's facade. Photo: P.Eastway

High Contrast Black-and-White

Many subjects that might be only moderately interesting in a normal black-and-white rendition become vivid graphic images when seen in high contrast. This rendition simplifies the gray scale into fewer steps. Light and very light tones are all made white; dark and very dark tones are all made black. Mid-range grays are telescoped into only two or three intermediate steps. Many photographers try to get this kind of image by using high contrast printing paper, but it is far more effective to use a high contrast film. Several manufacturers offer graphic arts films which have high contrast emulsions, but most are ortho-chromatic. That is, they are sensitive to blue and green, but not to red.

One of the most versatile films available for normal as well as special black-and-white effects is Kodak Technical Pan Film 2415. It is a panchromatic film (sensitive to all colors) with extremely high resolution (the ability to render fine details clearly). Its contrast can be varied

Simple subjects such as the one shown above can become the raw material for graphically powerful images. The same subject was rephotographed on high contrast film, given extended development, and printed on extra-high-contrast paper to produce the stark result at right.

widely simply by changing development. With low-contrast development it gives excellent full-range pictorial results. But it can also produce extremely high contrast results with an appropriate developer, as these pictures show. The instruction sheet supplied with the film tell you how to expose and develop it for various effects.

Certain subjects lend themselves readily to high contrast techniques. The woodcut-like version of this tiger was achieved by making a negative print of a high-contrast original. Photo: P.J. Bereswill

Special Black-and-White Films

There are two kinds of special films that can greatly extend the range of your black-and-white photography. Infrared-sensitive film will let you bring out subject qualities that are invisible to the eye. Chromogenic film will let you expose a roll at several different film speed ratings, and to subjects of very different contrast or brightness ranges, and yet use a single processing time for good results with everything.

Infrared Film. Sunlight and electronic flash are rich in infrared as well as visible wavelengths. Kodak High Speed Infrared Film 2481 has normal (panchromatic) color sensitivity, plus infrared sensitivity. Objects which reflect or emit infrared will register on the film as well as those which reflect light. Objects which do both will appear lighter than in a normal black-and-white picture, the difference being due to the extra infrared exposure.

When this film is used without a filter, the additional infrared exposure is only a small portion of the total exposure, so only a slight effect is noticed. But when used with a No. 25 red filter, blue and green wavelengths in the visible light are blocked, and the infrared exposure becomes half or more of the total effect. Outdoors, skies will go black, grass and foliage will go very light gray, or white; skin tones will be lightened, too, but veins, bruises, and other traces of blood just under the surface will be emphasized. A trial film speed with a No. 25 filter is ISO/ASA 50 in daylight.

To record only the infrared radiation, use a No. 87, 87C, or 88A filter. These filters look black because they block all visible wavelengths. Only trial and error will establish accurate exposure, because the infrared characteristics of a subject cannot be predicted accurately. Bracket widely in your first experiments. The film can be processed normally in any standard black-and-white developer.

Chromogenic Films. The newest black-and-white films have highly versatile chromogenic (dye-forming) emulsions. They are exposed normally, but are developed by the standard C-41 color negative process, or by equivalent chemicals supplied by their manufacturers. The final image looks like a black-and-white negative, but it is composed of black dye deposits instead of the conventional silver densities.

In general, these films give normal results with average sunlighted subjects when exposed at an ISO/ASA speed of about 400. Lower film speed ratings are used with high-contrast, long brightness-range sub-

jects, and higher speed ratings with low-contrast or dimly lighted subjects. At present there are two black-and-white chromogenic films. Ilford XP1 film can be exposed at speeds from ISO/ASA 100 to 1600; Agfa-Gevaert Agfapan Vario-XL Professional film can be exposed at speeds from ISO/ASA 125 to 3200. Specific exposure and processing information is supplied with the films and in brochures available from the manufacturers or distributors.

You can easily obtain otherworldly images like these by experimenting a little with infrared film and various filters. Do not rely on your meter for accurate light readings—infrared radiation cannot be measured by conventional light meters. Photo: H. Weber.

6

Night Photography: Equipment and Exposure

It is common to think that night photography means pictures of dark, dim subjects. That is sometimes the case, but you might be surprised at how often there is plenty of illumination. All sorts of locations, from city streets to shopping plazas to stadiums and outdoor arenas, abound with high intensity lights. Traffic on well-traveled roads produces light that can be seen as a glow in the sky over long distances. Even the light of the moon is ample for picture taking.

Night light is much less even than daylight. It tends to be spotty, with bright areas occurring as pools of light in much larger dim or black areas. Where the light is bright, it is seldom as bright as daylight, and it falls off in intensity very rapidly as the distance from the source increases.

Because night light other than moonlight comes from a variety of sources, it often has a strangely mixed, uneven color composition that can create unexpected results. And, the more sources there are, the greater the chance of confusing patterns of multiple shadows and highlights.

These are not drawbacks, they are characteristics of nighttime illumination. They are things you need to learn to see and to work with. There is no reason to let them defeat you, you can exploit them for strong, effective photographs.

Any adjustable camera can handle picture-taking after dark. It has long been true that with time exposures you could take a picture of anything you could see, no matter how dim the light. Modern high speed films and fast lenses make it easy to do that at more nearly normal shutter speeds, and even to hand-hold the camera in many situations. Generally, your exposure times will be longer than with daylight, so a camera support such as a tripod can be very helpful, even if it is not always essential.

Photography at dusk often means being confronted by a number of different light sources; all produce light of a different color temperature. In this case, the overall effect is further aided by the red streaks across the bridge—caused by taillights of cars passing by during the long exposure needed to record the image. Photo: T. Tracy.

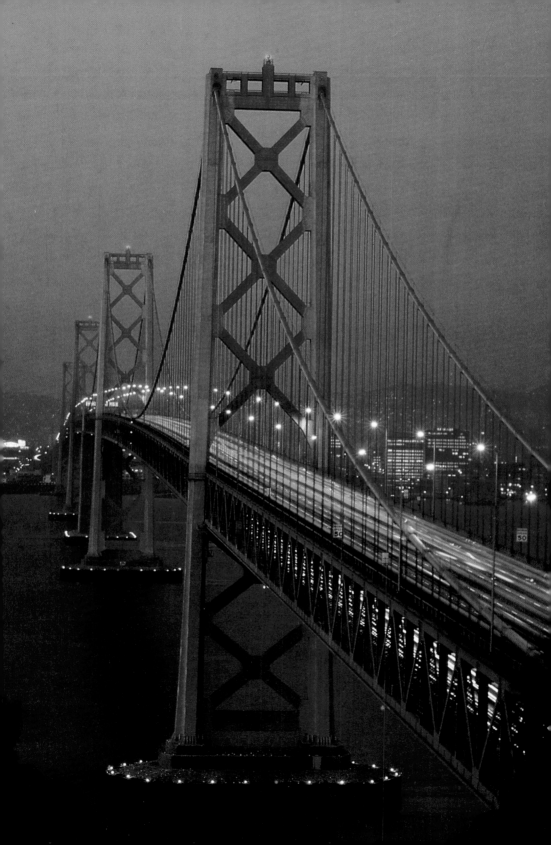

Tripods and Unipods

The most versatile camera supports are tripods which collapse to a size not much longer than your photo equipment bag. They range in quality from the excellent to the impossible, and you must choose carefully.

Sturdiness is a primary consideration. A fully extended tripod should be capable of supporting your camera outdoors when a slight breeze is blowing and be sturdy enough to insure a sharp photograph even when you make a long exposure. The best tripod will be strong, able to take considerable weight (a camera, motor drive, and extreme telephoto lens, for example), and have legs which lock firmly in place. It must be completely stable when extended to full height, which should be at least your eye level.

Your camera should fit securely on the tripod platform. The mounting screw should fit easily in your camera's threaded socket, and it should hold the camera firmly against the platform when the screw is tightened. If the tripod has pan (right-left) and tilt (up-down) movements, you should be able to lock the camera in any position with a long lens without fear that it will slip.

Finally, you should be able to operate the leg release/lock controls easily, and should be able to carry the tripod without trouble.

Although useful, tripods can be devilishly easy devices to trip over. A way to avoid problems (left) is to place the third leg toward the subject and stand in the vee created by the other two. Independent leg adjustment is an advantage in uneven terrain (right). Lower the legs one at a time until the camera is about level, then make fine adjustments.

Rather than a tripod, you might want to use a unipod, which is lighter and easier to carry. Most unipods are telescoping rods with a tripod screw on one end. (You can also use a tripod with just one leg extended as a unipod in crowded places; that will minimize the danger of its being kicked by passersby.)

To use a unipod, position your body so that your legs and the unipod work together to simulate a tripod. Do not lean on the unipod, keep your weight balanced on your legs. The unipod supports the camera from the ground up, and you steady it by pressing the camera against your head.

You can also press a unipod against a wall or other vertical surface to help steady the camera, or shorten it enough so the camera is at eye level when the other end is tucked snugly behind your belt.

To shoot over the heads of a crowd or other obstructions, use the unipod as a long handle to hold the camera up in the air. Choose a fast shutter speed to overcome camera shake, and release the shutter by means of the self-timer mechanism or a long accessory cable release.

When buying a unipod, carefully check the sturdiness of the extended leg. Some unipods have poor locking devices when extended— if you place a little body weight on the unipod, it will gradually sink into the collapsed position. Make certain that the leg can be locked into place at any point in its extension, and that your body weight, pressed against the unipod for steadiness, will not cause it to collapse.

There are several other unipod features to look for. The first is the mounting device that screws into the tripod socket of your camera. Some are rigid, forcing you to use the camera only in one position. Others are much like the pan head of a tripod, allowing you to tilt the camera at various angles. It is best to obtain the tilting variety since it will be more versatile. Check the control to be certain it will lock in place and stay there.

Even a sturdy tripod may not provide adequate support if you are photographing on an especially windy day. A water bag or other heavy weight, secured to hang directly under the center of the tripod, will help you get vibration-free photographs in blustery conditions.

Other Camera Supports

A shoulder pod is another good night photography device. This is a bracket that rests on your shoulder, with a platform extending from it to hold the camera. A shoulder pod can be used in places where a unipod or tripod might not be permitted. A folding shoulder pod can also fit conveniently into your gadget bag.

A variation of the shoulder pod is the gunstock mount, which allows you to balance the camera for more steadiness than is possible with normal handholding. The gun or rifle stock mount is usually used during daylight for following action.

Chest pods are short tubes designed to fit against the camera and your chest. Usually there is some sort of brace or flat chest plate to add steadiness.

A belt pod is similar to the chest pod. This time it is braced against your belt, and the sturdiness is somewhat similar to the unipod.

Tabletop tripods can also be of value. These are miniature tripods that extend to only a few inches in height. They are primarily meant to provide steadiness indoors with available light, but they can be placed on walls, stairs, or any flat surface outdoors.

This eminently pocketable device, known as a "clamp pod," can be used to attach your camera to any convenient ledge—a table top or car door, for example. Essentially a C-clamp with a tripod thread, this inexpensive item can be bought at most well stocked camera shops.

Special Supports. You can create a special camera support from practically anything if you have the time. For example, a photographer hired to take periodic slides night and day, of a construction project, was asked to take everything from the same viewpoint. The client wanted to be able to create the illusion of a several-months project going up in a matter of minutes. The solution was to imbed a tripod screw in concrete at the site. A concrete post became, in effect, a permanent unipod. Marks were made on the dried concrete top where the camera body would be placed. Then the camera could be perfectly positioned each time new pictures were taken.

A tabletop tripod is a handy device for steadying a camera against a wide variety of surfaces. To further minimize the possibility of camera movement, use a cable release.

You can buy C-clamps specifically made for holding cameras. These have a tripod screw attached and offer no risk of damage. Clamps sold this way, but with the addition of padded jaws, can be used for attaching the camera to a car window or a finished surface. Some are designed without the padding but with a screw for attaching the clamped camera to a tree or fence.

Improvising Supports. You can use almost anything available to steady a camera for a long exposure. Hold the camera against a door jamb, on a garbage-can top, along a stair railing.

Technique Tip: Handholding Long Exposures

If you do not have a tripod or other camera support at hand, try this technique to hand-hold your camera for exposures of a half-second or longer.

Pull the camera strap snug against the back of your neck and wrap the rest tightly around your wrists to take up the slack as you look through the viewfinder.

Lean back against a building, tree, or other support so that you form a kind of tripod with the fixed support. Your legs should come out at an angle, with your weight as evenly distributed as possible between all three support points: your two feet and the point of contact between your back and the wall.

Focus. Take a deep breath. Let it out smoothly about half way, and slowly press the shutter release. Don't breathe until you know the exposure has ended. If you have an SLR camera, you will hear the sound of the shutter closing and the mirror returning to viewing position. Only then should you breathe again.

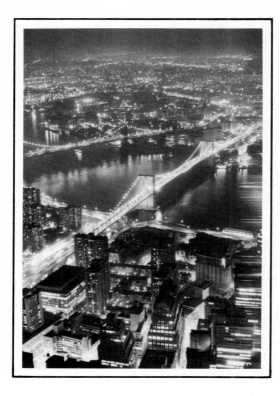

Photography at night is far more convenient with fast films—those with ISO/ASA speeds at or above 400. All black-and-white and certain color films can be "pushed" to further increase their usefulness at night. For best results, films used at higher ratings than the manufacturer recommends should have their processing modified, as explained in the text.

Films for Night Photography

All films are suitable for night photography, but they are not all equally convenient. Slow speed films require long exposures, and that has two disadvantages: You need a camera support, and there may be unpredictable color shifts in the resulting pictures. Methods of making long exposures successfully are covered later in this chapter.

An ISO/ASA 400 speed film will be your best choice for most night photography because it will let you hand-hold your camera in the majority of conditions. If you prefer to use a 200 or 160 speed film, you must give an additional one or one-and-a-half stops exposure—you can do that in many situations without difficulty.

There are several conventional and chromogenic 400 speed black-and-white and color negative films available, and at least two color slide films. One slide film, manufactured by 3M, actually has a rating of ISO/ASA 650 for tungsten light. When used with an 85B conversion filter, it can be exposed to daylight or electronic flash at an effective speed of 400.

When necessary, you can rate a film at a higher than normal speed to determine exposure, and give it modified processing to improve the results. Techniques for "pushing" films in this way are described at the end of this chapter.

Choosing a Film. Study your nighttime scene or subject carefully to determine what kind of film is most appropriate. Color film is excellent for many subjects such as street scenes with neon lights, or amusement parks, but a moonlit scene may be just as effective in black-and-white, since the colors may be so muted as to be almost indistinguishable. When in doubt, use color negative film. A custom lab can give you color or black-and-white prints from it, or color slides. Prints made from a color slide film lose more quality, especially in difficult situations such as night shooting, than do slides made from a negative film. In addition, color negative film has greater latitude than slide film, so you have more leeway in determining exposure.

You can use either tungsten or daylight type color film and get good results in almost all situations. In some cases, tungsten film will give you cooler (more bluish) rendition, and daylight film will give you warmer (more reddish) rendition. If you want to record things as accurately as possible, follow the recommendations in the accompanying table.

NIGHTTIME COLOR FILM CHOICE
For the most accurate color rendition use the indicated type of film for the listed subjects or conditions.

Daylight Type Film	Tungsten (3200K, Type B) Film
Brightly lighted streets, business areas, store windows	Outdoor lighted sports events
Entertainment district lights; lighted signs	Indoor sports events
Floodlighted monuments, fountains, architecture	Stage shows, circuses
Spotlighted performers	Floodlighted performers
Fairs, carnivals, amusement parks, fireworks	School auditorium and stage presentations
Skylines at sunset, twilight; distant lighted buildings	Swimming pools, ice arenas with overhead lights
Campfires, bonfires, fireplaces, flames (as subjects)	Close shots of subjects lighted by candles, flames
Christmas and holiday lights, lighted decorations	Church interiors, stained and colored glass by artificial light
Moonlighted scenes, subjects	

Determining Exposure at Night

Illumination at night is often spotty, and there is likely to be much less natural fill light in dark areas than in the daytime. You can use the same metering techniques as you would during the day, but you must use them with greater care and precision.

The most important rule in determining night exposure is this: Measure the brightness of the most important part of the subject, and be sure you are measuring only that. You seldom are attracted to a night subject because of what you cannot see—or can barely see—in the unlighted areas, so there is no reason to favor them; you will only run the risk of overexposing the lighted areas you do care about and of losing details there.

You can rely on an overall reflected-light reading to give you accurate exposure in floodlighted areas, such as stadiums and parking lots, and in landscapes fully lighted by the moon. But be sure not to include the dark sky in the area the meter sees.

Wherever the light is uneven or spotty, you must read from the subject. That means you must know exactly what size area your meter takes in, and then you must get close enough so the important subject tone completely fills that area. If you can't get close enough with your built-in camera meter, switch to a telephoto focal length to take the reading. A spot meter is extremely useful in night situations.

If you are relying on incident-light readings, you must get to the subject position. Do not try to take such a reading from a substitute location—your ability to judge accurately that "the light here is the same as the light over there" is greatly reduced at night.

Dim Light Readings. The cadmium sulfide (CdS) and "silicon blue" cells used in meters today are extremely sensitive; they can give exposure indications even under moonlight and candlelight. However, sometimes the reading is at the very bottom of the meter scale, where it is difficult to see the indication accurately, and sometimes there is not enough light to cause a reaction at all. Here's a trick to get a readable indication in such conditions.

Divide the ISO/ASA speed of your film by five, and reset your meter to the new exposure index. For example, with an ISO/ASA 125 film, reset the meter to 25. Then place a piece of white paper or cardboard at the subject position and take a reflected-light reading from it. The white surface is about five times more reflective than the average subject, so more light will reach the meter to cause it to react. By resetting the film speed, you have compensated for the extra reflectivity, so the meter's exposure indication will be accurate for the actual subject. If you do not want to change the film speed setting, take a reading from the white surface and give two f-stops *less* exposure than the meter indicates. The effect will be the same.

Because night lighting conditions vary so much, it is not possible to give a general rule of thumb such as the f/16 rule for estimating daylight exposure (see Chapter 2). However, there are specific sugges-

tions in the next chapter for starting exposures with a variety of subjects. Until you have some experience with night shooting, be sure to bracket your exposures from these or other recommendations.

Base your night exposures on the most important areas of the scene, keeping in mind the overall effect you want to produce. Accurate exposure readings are best gotten at night with sensitive CdS or silicon blue cell light meters. Bracketing exposures will further increase your chances of producing an effective photograph. If important subject areas are far away or expecially small, use a telephoto lens to narrow the field of view of your camera's light meter. Make your reading, then switch to the lens you need for the photograph you are after.

Long Exposures

Long exposures are often necessary at night simply to get a dimly lighted subject to register on the film. But long exposures are also useful to create expressive effects such as continuous streaks of light from passing traffic. Long-exposure effects are discussed in Chapter 8; here, let's concentrate on how to make such exposures properly.

Shutter Settings. Most 35mm cameras have shutter speed settings down to 1 sec. or 2 sec. Beyond that you must use a B (Bulb) or T (Time) setting. At the B setting, the shutter opens when you press the shutter button and closes when you release it. You must keep the button depressed for the entire exposure. If that is a matter of many seconds, or even minutes, it is best to use a cable release with a locking device that will hold the shutter open without continuous finger pressure on the cable.

Correct Exposure. Although sensitive exposure meters can indicate time exposures up to several minutes, they do not indicate *correct* time exposures for the following reason. In theory, a number of different *f*-stop and shutter speed combinations give equal exposures; for example, $f/16$ at $1/60$, $f/11$ at $1/125$, and $f/8$ at $1/250$ all give the same exposure. But when long exposures are used, the film does not react equally. With weak light the film needs extra exposure to build up the same image that it could record in a short exposure by stronger light. This is called the reciprocity effect.

Non-photographic light sources often do not contain all the colors of the spectrum and so will not reproduce as white. In this picture the greenish lights are characteristic of fluorescent tubes while the yellow ones are sodium vapor—frequently used for street lighting. Photo: T. Tracy.

Black-and-white films "fail" this way when exposures are longer than about one second; they produce weak, underexposed images. Some color films start to exhibit the reciprocity effect at 1/10 sec., others at longer exposures; the images are weaker, and some colors begin to shift unpredictably. The first indications of this problem in color pictures are dark areas that look greenish or purplish.

The first line of defense is to give more exposure. That's why it is especially important to bracket with additional, increased exposures whenever conditions call for a long exposure. For the most effective correction, development also must be adjusted for black-and-white films. Color film processing cannot be changed significantly, so corrective filters are used at the time of exposure. The accompanying tables can guide you in making correct time exposures.

LONG-EXPOSURE CORRECTION FOR BLACK-AND-WHITE FILMS

Meter-Indicated Time (sec.)	Open Lens Aperture	OR	Use This Time (sec.)	AND	Adjust Development
1	1 stop		2		10% less
10	2 stops		50		20% less
100	3 stops		1200		30% less

LONG-EXPOSURE CORRECTION FOR KODAK 35 MM COLOR FILMS

Film		Filter and Lens Aperture Adjustment for Exposure Time of (sec.)*			
		1/10	1	10	100
Kodacolor	II	+½ Stop CC10C	+½ Stop CC15C	+1½ Stops CC30C	+1½ Stops CC30C
Kodacolor	400	None	+½ Stop No Filter	+1½ Stops CC10M	+2 Stops CC10M
Ektachrome Daylight	64	None	+1 Stop CC15B	+1½ Stops CC20B	Not Recommended
Ektachrome Tungsten	160	None	+½ Stop CC10R	+1 Stop CC15R	Not Recommended
Ektachrome Daylight	200	None	+½ Stop CC10R	Not Recommended	Not Recommended
Ektachrome Daylight	400	None	+½ Stop No Filter	+1½ Stops CC10C	+2½ Stops CC10C
Ektachrome Infrared		None	+1 Stop CC20B	Not Recommended	Not Recommended
Kodachrome (Type A)	40	None	+½ Stop No Filter	+1 Stop No Filter	Not Recommended
Kodachrome Daylight	25	None	+½ Stop No Filter	+2 Stops CC10B	+3 Stops CC20B
Kodachrome Daylight	64	None	+½ Stop No Filter	Not Recommended	Not Recommended

*Lens aperture adjustment includes compensation for filters used. Color compensating (CC) filters in indicated cyan, magenta, blue and red densities are available from photo dealers.

Special Processing

When film is underexposed, results can be improved to some degree by giving it greater than normal development. The adjusted development cannot restore details that are lost in dark areas because of the underexposure, but it can improve what would otherwise be reduced contrast and color densities in middle brightness and highlight areas.

Pushing Film. When photographers "push" a film, they deliberately underexpose it by assigning it a higher than usual speed rating. This is often done so as to use a faster shutter speed or a smaller lens aperture than conditions would ordinarily permit. Doubling the film speed makes possible a one-stop (or one shutter-speed step) difference in the camera settings. Multiplying the film speed by four makes possible a two-stop change, which is the practical limit in almost all cases. To determine pushed exposure, simply set your camera or meter to the increased speed rating and proceed as you normally would.

Subjects and Films for Pushing. A film cannot usefully be pushed in all situations. First of all, underexposure will lose dark-area details, so there must be nothing important in those parts of the scene, or in areas with dark colors. Second, push processing builds density, so there should not be important details in the highlight areas of the picture—they will just be blocked up or washed out by extra development. In addition, push processing cannot produce absolutely accurate color rendition, and it increases the graininess of the image; your subject must be able to stand up to these factors.

Pushing is useful with normal contrast subjects photographed under weak, flat light, and with low contrast subjects; it will only increase the problems encountered with high contrast subjects or lighting. A scene in an alleyway lighted only by reflected glow, or a subject on a heavy overcast day can be improved by push processing. A person under a streetlight, in a spotlight, or in direct sun is not the kind of subject for pushing.

Since push processing builds contrast, slow speed black-and-white films are not a good choice; they have too much inherent contrast. Fast, 400 speed films, respond much better to push development because they have greater exposure latitude and lower inherent contrast. All color slide films can be pushed, but again results are better—and there is more advantage to be gained—with higher rather than lower speed films.

Push Processing. Conventional black-and-white films can be push processed in standard (*not* fine grain) developers by increasing developing time 50 percent; further increases in time will cause too much image-degrading fog and graininess. There are several high speed developers on the market which claim to increase film speed.

Their manufacturers specify increased film speed ratings and expect you to follow their processing instructions exactly. Almost all of them produce useable results, but some shadow detail is lost. Ask your photo dealer to recommend one of these developers if you want to experiment.

Chromogenic black-and-white films can be exposed at a variety of speed ratings with normal processing. Like color negative films, they cannot be push processed with good effect.

All color slide films except the Kodachrome films are developed by the E-6 process. Most custom color labs offer extra-cost E-6 push processing for films rated up to two stops (four times) more than normal. Kodak laboratories offer one-stop (twice normal speed) push processing for Ektachrome films. This service is available through dealers, or by purchasing an additional-cost ESP-1 mailer. Only one or two custom labs offer Kodachrome push processing, at considerable expense; Kodak does not offer special processing for these films.

While you can photograph in less light with push processing, you do pay a penalty in picture quality. Notice here the relatively grainy appearance and the de-saturated colors.

7

Night Lights and Night Subjects

Taking pictures at night is one of the most exciting ways to use your camera. You can isolate neon signs, see unusual patterns in flood-lighted buildings, and even record dramatic landscapes after dark. Some interesting images may result from the way moonlight affects the surroundings. Other images depend on the mood of dark colored shapes barely perceivable against even darker surroundings, with only a few key highlights for accent.

Lights themselves can make vivid images, and they stand out most clearly at night. There are reflections of lights, the tracks of moving lights—traffic, stars, fireworks, ferris wheels, and so on—and the patterns created when the camera is moved or the lens is zoomed.

There are just as many subjects and picture opportunities at night as during the day, but they are quite different. Night pictures are more likely to be about mood, drama, or patterns of colored light than day pictures. The most effective night pictures have greater graphic impact than day pictures, both in color and in black-and-white.

Street Lights. Street lights provide harsh, overhead illumination. Subjects requiring sidelighting, such as people, need careful planning if they are going to be photographed under them. However, the lighting works perfectly for wide-angle night scenes of large areas.

There are several different types of street lights. One type is similar to the standard tungsten bulb, a more powerful version of the lighting you have at home. Some cities use the far more efficient mercury-vapor lights, however, which are inconsistent in the affects they produce on film. Some seem to approach daylight. Others may have distinct color casts, which may be either warm or slightly green, depending upon the type of lamp. These are not as standardized as other types of lighting. In general, you will get the best results with daylight type color film.

At night, the light from passing cars, along with bright streetlamps and illuminated buildings, combine at night to cause a mosaic of colors against a dark background, giving life and character to scenes that might look mundane in the daytime.

Street Scenes at Night

A visually dull scene in the sunlight can take on an exciting appearance after dark. This is especially true of many street scenes. Neon signs, electric lights, and other sources of illumination create an entirely different set of colors, highlights, and shadows from what you see in the daylight daytime; they can transform an ugly setting into a dramatically interesting one.

Entertainment and business districts are more brightly illuminated than residential neighborhoods at night. The accompanying table gives suggested exposures for a great variety of night subjects and situations. The suggestions are all made at a single aperture, $f/4$, for convenience in comparing them. If you have a lense that opens to $f/2.8$ or wider, you may well prefer to work at maximum aperture. That will let you use a faster shutter speed for hand-holding your camera, and will decrease the depth of field so that foreground and background details will be more out of focus. If you want to record blurred movement, use a smaller lens aperture and a correspondingly slower shutter speed. Use a mailbox, lamppost, or any convenient support to help steady your camera.

Reflections. City lights are visually interesting subjects in themselves. They are even more interesting if there has been rain and they are reflected in the wet streets and puddles. This gives a double image

Brightly lighted downtown areas will usually provide you with enough light for shake free exposures without a tripod. Use lenses with maximum apertures of f/2.8 or larger and shoot wide open, to get the fastest shutter speed you can. Photo: K. & I. Bancroft.

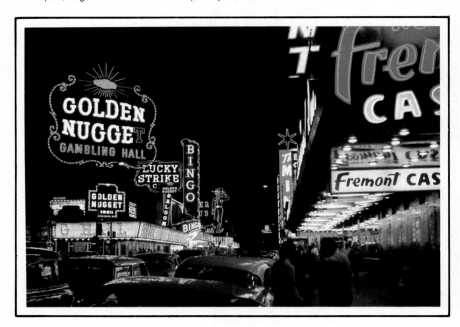

of light and color, which turns an ordinary scene into a visually arresting one.

The exposure for reflections in water should be bracketed, based on readings for both the water and the original light source. First take a reading from the reflection, then take a reading from the light source. If there is a difference, bracket between the two figures. Remember that color negative film has enough latitude to allow you to record the darker image and still retain detail in the slightly overexposed, brighter areas. Take advantage of this by exposing for the reflection and letting the original lights be recorded as they will.

If you are using color slide film, you will get better results if you expose for the brightest element, usually the lights themselves. The slightly darker reflection will have richer colors if it is underexposed by no more than one *f*-stop. Again, bracketing helps, although if there is no more than a one *f*-stop difference, exposing for the bright lights will also give you an excellent reflection.

NIGHT EXPOSURE RECOMMENDATIONS

Subject, Lighting Conditions	Camera Settings with ISO/ASA 400 Film*
Full-moon:	
Landscapes	1/30 *f*/4
Snow scenes	1/15 *f*/4
Close-up subjects	1/60 *f*/4
Sky, 5–15 minutes after sundown	1/125 *f*/4
Lighted signs; spotlighted performers	1/125 *f*/4
Very bright streets; floodlighted outdoor sports events; store windows	1/60 *f*/4
Fully-lighted stage scenes; indoor sports events; business district streets	1/30 *f*/4
Fairs, carnivals, amusement parks	1/15 *f*/4
Subjects by fireplace, campfire, bonfire	1/8 *f*/4
Christmas and holiday lights; floodlighted monuments, fountains, architecture	¼ *f*/4
Subjects under streetlights; candlelight close-ups	¼ *f*/4
Lightning	B or T *f*/11
Fireworks	B or T *f*/16

*Other, equivalent settings may be used. For other film speeds, increase exposure as follows: ISO 200–250, +1 stop; ISO 100–125, +2 stops; ISO 50–64, +3 stops. Bracket exposures for best results.

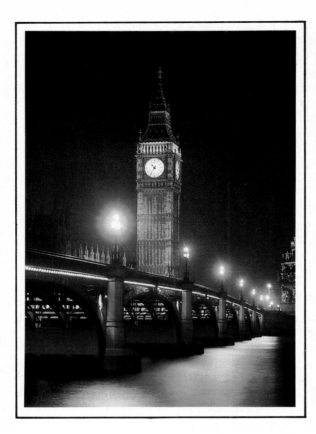

Long exposures can sometimes cause color shift, giving most subjects an unreal appearance. This is not always a disadvantage—in this case, the color shift gave Big Ben and Westminster Bridge a coppery, dreamlike appearance. Photo: T. Tracy.

Cityscapes and Buildings

Give yourself a little visual distance from the heart of the city and you have a new challenge. Position your camera far enough from a cluster of downtown offices, steel mills, apartments or whatever exists where you are recording, and you will see an exciting nighttime urban landscape. The lights seem bright and you may think that everything can be recorded with handheld exposures.

The lights appear bright only because they are in contrast with the darkened sky. While each light source can probably be photographed at exposures between 1/30 sec. and 1/60 sec. at $f/2.8$, such exposures will not record the general outline of the city's buildings, which is a more interesting subject. These exposures are too slow to record shadow detail.

Mount your camera on a tripod and plan to use an entire roll of film for your experimenting. At ten minutes before total sunset, there

often is enough light to provide an outline of the buildings. Usually an exposure of 45 sec. at $f/16$ with ISO/ASA 400 film will give you an excellent record of the cityscape. Naturally, you should bracket from there.

Be careful to position your tripod on solid ground if you are taking pictures of a high traffic area. For example, some cities have bridges that offer excellent views of industrial areas. But the traffic passing on the bridge might create enough vibration to blur your image, especially if you are making long exposures. If this is the case, either move to firmer ground or photograph later at night when there is less traffic.

Night photography sometimes has to be done in fairly windy locations. If you are using a tripod, try bracing it with sand bags or other weights. The more weight on the tripod and the better the legs are "packed" with such weights, the steadier your picture will be. Some tripods come with metal points that can be dug into the ground. If your legs have these points, use them for extra steadiness.

Buildings. Many communities have buildings with unusual architecture, special historic interest, or dramatic monuments. Frequently the exteriors of these structures are lighted after dark. Their appearance is dramatically enhanced by the bright light and the shadows of the floodlighting as well as by the softer light from the moon.

If a building is illuminated only by the full moon, an exposure of at least 45 sec. to a minute, bracketing from a wide open lens, will bring out the detail with ISO/ASA 400 film. Extreme shadows can be avoided by making your pictures the last ten minutes before complete sunset, when there is enough light for relatively short (10- to 15-second) exposures.

To get a picture of a naturally-lighted exterior with the lighted interior visible through the windows, you must make two exposures. Lock your camera firmly in place on a tripod and make the first exposure, for the naturally-lighted exterior, shortly before sunset. After the sun has gone down and the sky is dark, make a second exposure on the same frame, with the shutter speed and f-stop set for proper exposure of the light from the windows. The unlighted building exterior and the dark sky will not add significantly to the previous exposure, so just the interior light will be recorded this time. Check your camera instructions for the best method of making a double exposure. With many models all you have to do is depress the film rewind button as you stroke the thumb lever to cock the shutter without advancing the film.

A building that is partially lighted with floodlights or similar illumination is much easier to handle. The secret is to isolate those areas which are bright and concentrate on them. Look for ornate overhangs and doors that are carved or have unusual designs. Seek out attractive landscaping which you can use as a frame. Flowers, hedges, tree branches, or other foliage make good frames. Excellent results can be obtained with a wide-angle lens set to give you great depth of field.

Lighted Interiors

Arcades, cafeterias, fast-food establishments and similar places make bright and garish subjects. Look at the harsh interior lights of such places after dark. From the outside, every customer and employee seems like a colorful character who can easily be captured with a moderate telephoto lens.

There are several ways to take an exposure reading for such scenes. One approach is to get close enough, either physically or by attaching a short telephoto lens, so your camera's exposure meter is reading through the glass of the windows. You can also go inside and take a reading while waiting for service.

As a general rule, most such places can be recorded effectively with a reading of 1/60 sec. at $f/3.5$ with ISO/ASA 400 film. Bracket slightly, but you will find that this usually works. There can be movement, especially in the kitchen, which a slower shutter speed will not be able to stop. Most of the customers are more casual and can be photographed with a slower speed as they pause in the midst of their meals.

Display Windows. Display windows are often fascinating at night. Many stores make great efforts to create imaginative displays of jewelry, toys, and other merchandise. Photography of such windows can be an interesting challenge.

During the daylight hours, window reflections are a serious problem. The external lights, especially brilliant sunlight, may reflect from the glass, overshadowing the internal lights. At night, with no sunlight and with strong enough internal lighting, the reflections are reduced, although headlights from cars and overhead street lights may be reflected in the glass. A polarizing filter is handy at night, though seldom necessary to the degree that it is during the day.

Unless street lights or moving automobile headlights are reflected in the glass, there should be no glare. As a precaution, move about while you are studying the window through your camera. Angle your lens so there is a minimum of reflection. Then take the picture if this angle is effective. Focus through the window glass on the objects inside.

The exposure meter reading can be made directly through the glass. Hold your camera against the display window and let your meter read through the surface. Then bracket your metered exposure by one f-stop over and one f-stop under, to insure a correct exposure.

Daylight film is quite effective with display windows. Many stores use display lights with colored filters over them. The basic lighting might be tungsten, but the filters change the colors. A daylight film will probably give the most effective color possible. Negative film gives you the best latitude, and a custom printer can correct some of the color and exposure if it is incorrect. In-lab correction should not be counted upon, but a minimum amount of change is possible.

Even though this scene was recorded outdoors, tungsten-balanced film produced the more accurate rendition of tones—the building was illuminated with tungsten lamps. Daylight-balanced film produced the overall yellowish cast shown in the smaller photograph.

Often, both types of film will give you good photographs; your choice as to which is better will be largely a matter of taste. Photos: A. Balsys.

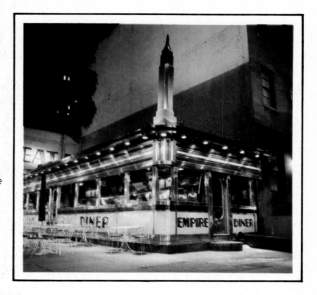

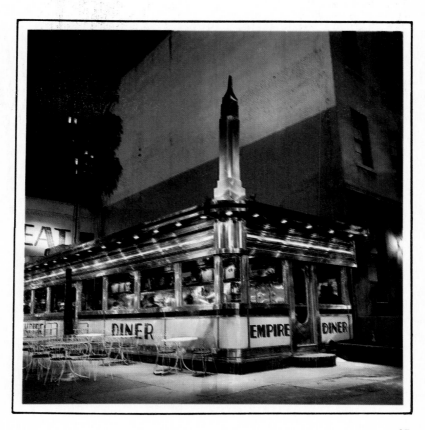

Night Sports Events

Sporting events are exciting to record at night. A football, baseball, or soccer game is fast paced, visually interesting, and somehow more dramatic after dark. The harsh contrast between the floodlighted playing area and the deep shadows of night make the colors of the uniforms stand out dramatically.

The lights used by high schools, colleges, and professional teams are usually quite bright. Film rated at ISO/ASA 400 and faster can usually be used with shutter speeds of 1/250 sec. to 1/500 sec.

Lenses. Relatively high-speed telephoto lenses—those with a maximum aperture of $f/4$—are desirable. You should also follow the rule for handholding telephoto lenses (see the Technique Tip).

For most team sports, you will not require an extreme telephoto lens to shoot from a position along the sidelines. This is because it is the teams' interaction, and not individual players, that provides the visual excitement. You can stand on the sidelines with nothing longer than a 135mm lens and still obtain effective photographs. A 200mm

Technique Tip: Handholding Telephoto Lenses

Besides magnifying the size of the image, telephoto lenses will also magnify the effects of any vibration that occurs while the picture is being taken. The longer the lens, the greater the opportunity for image blur caused by camera movement. Ideally, a tripod or other firm support is recommended for use with a telephoto lens.

However, under certain circumstances, it may be necessary to handhold a telephoto lens, and there is a rule of thumb for doing this effectively. The minimum shutter speed should be no slower than the number closest to the focal length of the lens being used. To do this, make a fraction with the number "1" over the length of the lens. For example, with a 135mm lens, the fraction would be 1/135; the closest shutter speed to this is 1/125 sec. With a 200mm lens, the minimum shutter speed would be 1/250 sec.; a 400mm lens would require 1/500 sec., and so forth.

When using a zoom lens, use its longest focal length to determine the handholding speed; you can't stop to change shutter speeds when zooming to cover sports action.

lens is helpful and gets you closer to the action when it goes downfield. However, it is not essential.

The exception is baseball, where individual players are widely spread about the playing field. Using a 135mm lens to try to isolate an individual player is extremely difficult. A 200mm lens will help you capture a runner sliding in to a far base, with the opposing player trying to tag him; but for baseball in general a 400mm lens or even longer is a definite help. Fortunately, you can usually use a unipod in the stands to support your lens without disturbing the others in the bleachers.

At amateur games, you can frequently get permission from the coaches to go onto the field. As long as you keep out of the way of moving players, do not make a nuisance of yourself, and do not create a situation where you are endangering anyone by your location on the field, you can move freely. Remember that the bright lights can momentarily blind a running player, so stay well away from any action that is taking place on the field.

Exposure. The lighting on most athletic playing fields is fairly even. You can arrive early and take your exposure meter reading directly from one of the players warming up on the field. If you can get onto the field, you can use a moderate telephoto lens and move in close to the player; this will give you the effect of a built-in spot meter. This trick may also work if you must remain in the stands, but you will need a longer lens.

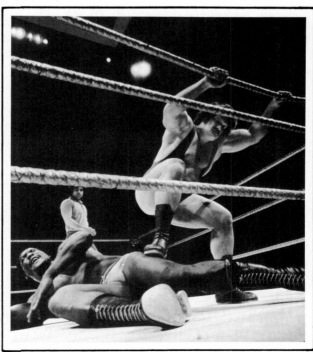

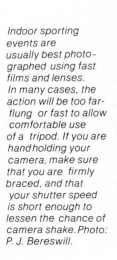
Indoor sporting events are usually best photographed using fast films and lenses. In many cases, the action will be too far-flung or fast to allow comfortable use of a tripod. If you are handholding your camera, make sure that you are firmly braced, and that your shutter speed is short enough to lessen the chance of camera shake. Photo: P. J. Bereswill.

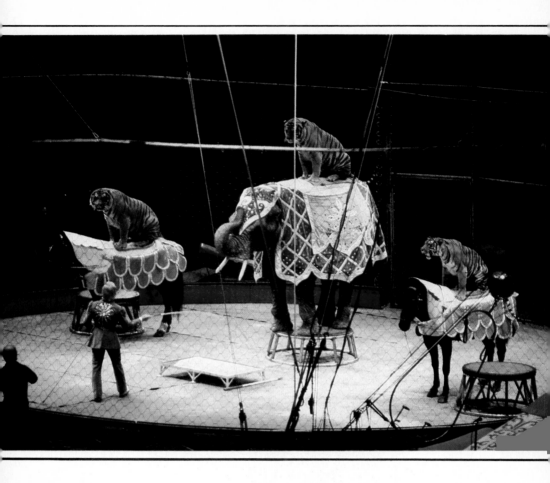

As with sports photographs, pictures of events such as circus performances require the use of fast films and shutter speeds (about 1/125 sec. or shorter) to freeze the movement of animals and performers. A long lens will usually be necessary as well. Bring along a tripod or other camera support to increase your chances of recording the subject sharply. Photo: C. Child.

Carnivals, Fairs, and Amusement Parks

Amusement parks, fairs, neon signs, and similarly strong lights are interesting subjects for your night photography. They are usually bright, allowing exposures of 1/60 sec. to 1/125 sec. or faster with

ISO/ASA 400 film. Fast film is recommended because some fairs have a broad range of lighting conditions depending upon where you are trying to take pictures. While a neon-lighted ferris wheel might allow you to use 1/125 sec. at $f/4$, a game on the midway might be illuminated by regular incandescent bulbs that are dim enough to require an exposure of 1/30 sec. at $f/2.8$. Both of these shutter speeds can be handheld with relative ease. A slower film might be fine for the rides with stronger lights but of no value when trying to handhold pictures of other events at a fair or amusement park.

Light Blurs. You can use a slow shutter speed, stopping your lens down to compensate, in order to create a whirling color effect from the moving lights on some of the rides. To understand this effect, look at the ride when it is not moving. You see each light bulb distinctly. Now watch the lights as the ride begins to move. The faster the ride goes, the more the lights seem to blend together. Your eye perceives a single blur of colored light, which will be recorded on the film when you use a slow shutter speed. When the lights are two or more different colors, the spinning lights lack the color distinctions. All the colors seem to blend, forming a different color, that is a combination of the individual ones. This effect is dramatically appealing.

People and Scenes. Most lighting at amusement parks is overhead lighting. This throws peoples' faces into shadow. Yet, people attending parks, fairs, and other amusement areas are marvelous subjects. There are smiling faces, children happily smeared with cotton candy and ice cream, lovers strolling hand-in-hand, determined youths trying to win prizes. Photograph them in areas of high illumination, exposing for the faces and letting the lights be overexposed. A good place to do this is a theater marquee, where hundreds of lightbulbs provide adequate light to photograph people in the ticket line or casual passers-by. A popcorn stand at a carnival will have a spillover of light from within, that will enable you to capture the faces of children standing by the window, eagerly anticipating their long awaited treat. A midway will have lights for the games spilling onto the players.

To take an effective reading of this reflected light with your camera's built-in meter, you need to get as close as possible to the subject you want to record. Otherwise, the extremes of light and dark areas surrounding the subject can mislead your camera's meter into overexposing the scene. If you are using color negative film, remember to expose for the darkest areas you wish to record and let the lighter areas take care of themselves within the latitude of the film.

Night Flash

Direct flash is easier to use at night than in daylight or with other available light. When you are indoors, or outdoors with buildings all around, the flash casts a harsh shadow. At night, in the open, the light can be used directly against your subject because it dissipates in the darkness. No confusing background shadows are created.

Your flash should always be either separate from your camera or raised above it. Flash mounted close to the lens can cause red eye—the image of the light reflecting off the retinas of the subject's eyes. Putting distance between the flash and the lens axis will prevent red eye.

You can also make use of a slave flash. This is either a special electronic flash or a regular one to which a light-sensing cell has been added. The special slave flash units have a built-in sensing cell. When the main light is flashed, the light travels so quickly that it can reach the sensing cell of the slave and trigger it, so that both flash units work in unison.

Slave units are excellent for nature work at night. You can have your camera's main flash aimed toward a bird's nest or animal hole. A second, and perhaps a third, flash unit (either a slave or equipped with a slave trigger) can be placed so they will give effective cross and fill light on the subject. Again, you do not have to worry about the background as long as there is no large object close by, that can cast unwanted shadows.

Night Sports and Flash. Supplemental lighting should not be used at night sports events, even though many electronic flash units are now available with a telephoto capacity. (This means that you can be 40 feet or more from your subject, using a 135mm or longer telephoto lens, and still get enough light from the flash to make an exposure with high-speed film.) The problem is that the flash is likely to distract the players or accidentally blind them for a moment if they are closer to the light than you realize. Your flashes can cause injuries and so should be avoided. You will probably see electronic flash used by others, especially at small schools where spectators like to take pictures, but you should not do the same since you know the risks involved.

You can use electronic flash effectively for half-time and sideline activity. Marching bands and cheerleaders can be recorded in this way. However, you will find that since the marching bands are on the same field as the players, the identical lighting conditions prevail and the extra light is not necessary. They are also likely to be more static than the players, and you can take this advantage to use a slightly slower shutter speed and smaller *f*-stop for a greater depth of field.

The cheerleaders, when working near the stands, are often away from the main illumination of the playing field. Take a separate meter reading for them so you can expose properly. They may be far enough from the action that you can safely use a flash when recording them, switching to available light when you turn back to the playing field.

This kind of over exposed, washed-out picture will result if you try nighttime flash with the flash unit too close to your subject, or set to too powerful a setting. Photo: J. Alexander.

Here, correct balance of electronic flash and existing light (as described in the text) provided full illumination of the model and a good rendition of background tones. Photo: J. Alexander.

Photography by Moonlight

The moon is not a direct source of light, it simply reflects sunlight. The moon's brightness is estimated to be 1/600,000 the brightness of the sun, so you can't escape the need for long exposures. That means you will need a tripod or other camera support, and that you will have to compensate with extra exposure, as explained in Chapter 6.

The accompanying table gives some exposure suggestions as a starting point. These exposures include the required compensation for a long exposure, and they assume that the moon is full. A half-moon gives out less than half the light of a full moon. Instead of just doubling your exposure, which seems logical, you will need to triple it.

Successful photographs of the moon require as short a shutter speed as you can get away with—extremely long exposures will cause the moon to register as a streak or blur. Use a fast film (ISO 400 or so) for this kind of photograph. Photo: D.E. Cox.

The moon is constantly moving across the sky. The rate of movement is so slow as to be almost negligible with fairly short exposures. During exposures of several minutes, the moon will travel slightly and will record as an elongated sphere if it is included in the picture. Because of this, many photographers combine high-speed film with wide lens openings in order to insure that the picture will show the expected roundness of the moon.

While moonlight itself has a full spectrum of colors, by the time the light strikes the earth it appears to have quite a bit of blue. A skylight filter helps reduce this problem, though it usually cannot be entirely eliminated. You may prefer this bluish cast because people expect to see it, and therefore it looks "real."

At night, rural areas usually have only moonlight as the source of illumination. Look for interesting silhouettes against the sky, such as barns, and animals that will stand still long enough so a slow shutter speed will not show movement. You might want to try using your normal lens wide open with the shortest shutter speed possible. At dusk, when the light has almost completely faded from a scene, you can obtain strong outlines of rolling farmland, barns, homes and animals. Your main point of interest is the bright moon, but the rest of the area is shown to excellent effect. Remember that negative film has a greater exposure range than slide film.

EXPOSURE GUIDE FOR FULL-MOONLIGHT SCENES

Situation	Film Speed (ISO/ASA)	Exposure (or equivalent)
Landscape	50–64 125–200 200–400	30 sec. at f/2 15 sec. at f/2 8 sec. at f/2
Landscape under snow	50–64 125–200 200–400	15 sec. at f/2 8 sec. at f/2 4 sec. at f/2
Cityscape or Skyline around sunset (with building lights)	50–64 125–200 200–400	4 sec. at f/2.8 1 sec. at f/2 1 sec. at f/2.8
Skyline 10 min. after sunset (with building lights)	50–64 125–200 200–400	1/30 sec. at f/4 1/60 sec. at f/4 1 sec. at f/2.8

8

Special Night Effects

You can take advantage of night conditions to create many kinds of special-effect photographs that would be very difficult or even impossible during the day because the fully lighted surroundings would mix in confusingly, or would make the effect imperceptible.

Some of these effects are matters of pure illusion. They will let you make it look like night when it wasn't. They will let you show things that weren't really there—or make invisible things that were really there.

Other "effects" are really techniques for solving difficult picture problems or for photographing special subjects. They will help you extend the capabilities of your film and equipment. They will show you how to make light go farther and do more than normal. They will explain how to stretch and divide time so that it is an asset, not a limitation for exposure.

Special effects and techniques are simply show-off tricks when used for themselves; they have no inherent function or meaning. Their real value is as a means to an expressive end, to help you make an illustration that does a particular job of communication. Then the effect becomes effective. It becomes invisible, and the image truly emerges.

The ideas and illustrations in this chapter may be just the answer to creating some of the pictures you have in mind. Or, you may be able to adapt their techniques to your own purposes. Think of them as starting points, and let your imagination go from there.

Fireworks displays are a favorite subject for many color photographers. Making exposure readings in situations like this is all but impossible; mount your camera on a tripod, leave the shutter set to "B," and keep it open for the duration of the explosion. Photo: G. Bull.

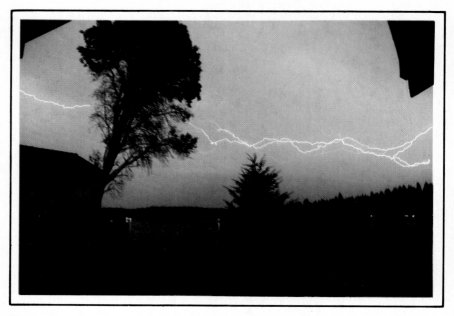

Photographs of lightning work best if you leave your shutter open long enough to record a number of lightning flashes. Single bolts of lightning are usually too thin and small to produce appealing images. Photo: T. Thompson.

Sky Shooting

Fascinating things can be seen in the sky at night, long after the last traces of sunset have disappeared. They include the stars and various natural displays, lightning, fireworks and, of course, the moon. You do not need a telescope or special equipment to photograph these things, your camera and conventional lenses can produce fine results. Pictures of the moon are covered on the following pages; here let's consider the other sky phenomena.

Star Trails. A short exposure with your camera pointed at the night sky will show the stars as nothing but pinpricks of light. But a long exposure can record an intriguing pattern of light streaks with various colors and intensities. Because the earth rotates during the long exposure, each star's image moves across the film, leaving a trail. Color effects occur because the faint sky glow builds up during the long exposure, and shows through the star trails to various degrees. If you frame the picture to include horizon elements, they may be quite visible in the picture, even though dim in the scene, because of the total exposure that accumulates.

To make star trail pictures, simply set your camera on a tripod and lock the shutter open on B or T. Make sure it is shielded from local light sources to avoid glare effects. You can use any kind and any speed film, but you must test to establish the best exposure. To make a test on one frame, start with your lens at its widest aperture and make a five-minute exposure. Block the lens for one minute and close it down one *f*-stop setting. Make a second five-minute exposure. Continue this procedure until you have made exposures at the first five *f*-stops of your lens. Examine the processed results to see which *f*-stop gave the best brightness in the trails; the one-minute intervals between exposures will help you distinguish among the results. Use that *f*-stop to make actual images. The exposure time is not significant, except that the longer the exposure, the longer the star trails will be. It may take two to four hours to get really interesting results, so prepare a way to make yourself comfortable.

Aurora Borealis. The Northern Lights can be captured with a 400 speed film, or with a 200 speed slide film push processed one stop. Many color labs offer this special processing, and Kodak labs provide it when you submit Ektachrome film in the ESP-1 mailer, available from photo dealers. These displays vary in color and intensity, so proper exposure is a matter of trial. Use the widest aperture on your lens, and take various exposures from one second to two minutes or longer.

Lightning. Just as you can't predict where lightning will strike, you can't predict when it will flash. So, your lens must be open on a time exposure setting, aimed in the direction of the storm, until something happens. Use *f*/11 with an ISO/ASA 400 film, *f*/5.6 with a 125 speed film, or *f*/2.8 with a 25 speed film. A single lightning bolt may look thin and lost in the frame, so leave the shutter open until three or four flashes have occured. If the storm is coming your way, be sure you and the camera will be protected.

Fireworks. It's possible to frame fireworks shots "on the fly," because you often can see the trail of an ascending skyrocket and can follow it with the camera until it explodes. But the burst itself takes a second or two to develop fully and burn out, so you can't get steady pictures if you handhold the camera. Instead, use a tripod and a normal focal-length or wide-angle lens aimed at the sky area where the display is happening. Open the shutter on B or T at *f*/16 with a 400 speed film (*f*/8 with a 125 film, *f*/4 with a 25 speed film). If you are some distance away, fill the picture by recording two or three bursts before advancing the film. Cover the lens between bursts if they occur several seconds apart. This will eliminate building up exposure from stray light, which might wash out the fireworks colors a bit.

Moon Pictures

The moon is a marvelous subject. Its major details are clearly visible to the naked eye, its shape changes throughout a 28-day cycle, and its color varies with changes in the earth's atmosphere. As a subject itself, or as an element in pictures of other subjects, the moon holds visual fascination for almost everyone.

Film and Exposure. The light of the moon is simply direct sunlight reflected toward the earth, so daylight type color film will record its colors best. Moon pictures in black-and-white are effective, too. Since the moon's surface is almost as reflective as average earth subjects, and it is lighted by the sun, basic exposure is easy to compute from the f/16 rule of thumb: Use a shutter of speed of 1-over-film-speed at $f/16$. For example, with an ISO/ASA 125 film, use 1/125 sec. at $f/16$, or equivalent settings. The light on the moon is constant, so exposure is the same whether you are photographing a full moon or just a crescent sliver. However, you will need greater exposure to record the ring of light that sometimes appears around the moon, or to compensate for night mist, thin clouds, and other atmospheric effects.

Image Size. Because the moon is at such a great distance, it is disappointingly small in pictures taken with normal focal-length lenses. Longer lenses give bigger images, which are much more satisfying. You can figure out just how big the image will be on the film this way: Divide the lens focal length (in mm) by 110. With a 50mm lens, the moon image would be only 0.45mm (about 0.017″) in diameter (50 ÷ 110 = 0.45). However, with a 500mm lens it will be ten times bigger, 4.5mm, on the film, and that will give a satisfyingly large image when a slide is projected or an enlarged print is made.

Using a long focal-length lens is the key to getting a big moon along with your subject in a single exposure. Suppose you want a large moon beside a tall building. If you use a 35mm wide-angle lens to fill the frame vertically with the building, the moon will be a bare pinprick. Instead, use the longest lens you have—say it is 350mm—and back off with the camera until the building again fills the frame. It will be the same size as before, but the moon will be ten times larger alongside.

Adding Moons. You can add a moon to any print by first printing through a moon negative, then through the negative of the other scene. If you take slides, it is not too effective to simply sandwich a moon slide with another, because the dark sky in the moon image blocks light from the other subject. But you can do it with double exposure, one for the moon, the other for the additional subject. Since you may want to take other pictures before completing the moon image, it is easier to prepare a stock of moon exposures ahead of time, as follows.

Some night when the moon is full, mark a starting point on a roll of film as you load your camera. A scratch mark connecting the first two sprocket holes to engage the teeth on the film advance wheel is a good reference. Then shoot a variety of moon images against the dark sky, exposing just for the moon. Use various focal-length lenses, or

zoom lens settings, and keep notes on the image size and location in each frame: small, upper right, vertical; big, middle left, horizontal; etc. When you have exposed the entire roll, rewind the film but stop before the tongue is pulled into the cartridge. Label the cartridge clearly, and keep it in the refrigerator in a plastic bag if it will be some time before you take the next step.

When you are ready to create your moon illusions, reload this roll, aligning the marked starting point precisely as before. Then go out to double-expose a variety of subjects with your moons. Refer to your notes so you can frame each picture with nothing overlapping the moon position. Use normal exposure for the second subject at night, or shoot day for night as explained earlier in this chapter. The entire procedure is sneaky, but it works like a charm.

The moon provides no light of its own—it merely reflects light from the sun. In this scene light from the sun illuminates the mountains and the moon. Photo: T. Tracy

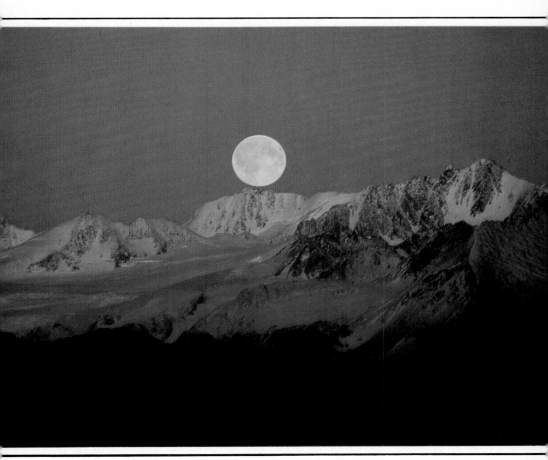

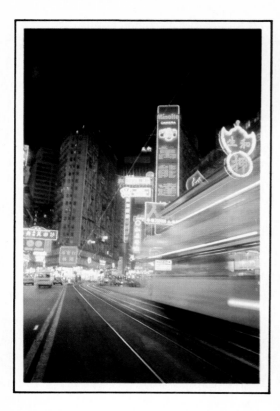

In most cases, subject movement is something to be avoided; however, there are times when it can be used to advantage. In this photograph, the trolley streaking across the right edge of the frame adds a sense of life to the street scene. Photo: R. Sammon.

Time, Movement, and Multiple Exposures

We have already discussed time exposures for the purpose of recording clear images of subjects under dim light or other difficult conditions. But long exposures—either as a single continuous exposure, or broken up into a series of short exposures—can also be used expressively. They are the way to record the flow of movement, to record the same subject in many different picture locations, or even to eliminate moving subjects from a picture.

Movement Paths. Very long exposures of the night sky will record star trails. Shorter time exposures are effective for turning the lights of passing traffic into fluid lines of brilliance gracefully flowing through your pictures. Set up on a tripod, and take an exposure reading directly from the passing headlights. Figure the aperture required for an exposure of ten seconds or longer, but open up one stop from that as a starting point. Approaching headlights will create ribbons of white through the picture, receding taillights will create narrower stripes of red. Surrounding, stationary objects will record in proportion to their various brightnesses.

If you want to include a sharp image of a passing car, fire off an electronic flash unit as the car passes the camera. Set the flash for proper exposure at the distance to the car, based on the *f*-stop you have set the lens to.

Eliminating Movement. If you divide a long time exposure into several very brief exposures at different moments, nothing that is moving in the scene will be recorded. It will be in the same place for only a fraction of the total time, and so will not register on the film. This is the way to eliminate pedestrians in street scenes, or traffic on highways in landscapes. It is a technique widely used to get uncluttered architectural photographs when the light is right but the street is busy. For example, if you set up for a 14-second exposure, you can give 14 one-second exposures at various times, even while someone is passing by; simply do not give more than two or three exposures with people or traffic in the same place. Block the lens with a black card between exposures; there is too much risk of moving the camera slightly if you open and close the shutter repeatedly. And keep accurate count of the exposures!

Painting with Light

Sometimes you will find that although you are prepared to add light to a night subject, your light source is not big enough to cover the entire area. You might have a single light with which to try to illuminate the entire face of a building or a sign, for example. Or you might want to use it to add light in the shadows both to the left and the right of a subject that is in existing light. You can do it by using your light source as a moving illuminator to "paint" with light.

Covering an Area. Let's start with a continuous light source, such as a floodlight. To illuminate a large area, set your camera on a tripod and aim your light at the subject to see just what the coverage is. Notice carefully where it falls off and where additional light is needed. Now take an exposure reading to find what *f*-stop to use for a one-second exposure. Turn off the light and open the shutter on B or T. Turn on the light and slowly move it back and forth across the entire area, making sure that it shines everywhere, but that each section gets no more than one second of light. This is a bit tricky to judge, but you'll get the knack of it with practice. If necessary, walk to the left and to the right so the floodlight is the same distance from each part of the subject during the time that part is illuminated. Do not get between the lens and the area being lighted, or your body will register as a silhouette. And never let the floodlight, or even the glaring rim of its reflector,

An electronic flash unit is an excellent "painting in," tool for those instances when the illumination of buildings at night is uneven or too dim. To make this picture, the camera shutter was left open while the photographer fired a series of flash bursts at close range to the building, flooding it evenly with light. Photo: D. Mansell.

face the lens. It may help to have an assistant block the lens each time you have to reposition the light.

With an electronic flash unit, simply open the shutter on B or T and fire the flash manually each time you point it at a different part of the subject. Set the lens at the *f*-stop required for proper exposure with the flash at the camera. Then move the unit to exactly the same distance from the subject for each part of the exposure. This is important, because the exposure is determined by flash-to-subject distance. Again, do not get between the light source and the camera, and do not let light spill toward the camera position.

To "paint" in colors, use different color filters in front of the flash in various locations. If you use unfiltered flash for a foreground subject, you can paint in the background in one or more colors. The possibilities are almost endless.

Building Up an Area. If you cannot get close enough to a subject to light it sufficiently, you can use a time exposure with a continuous light source. With a flash, you can fire it off several times to build up light, and thus exposure, in the area. The question is: How many times must you fire the unit? To get the answer, determine how many stops difference you want. Express that as how many times the light must be increased. Fire the flash a total of that many times. The accompanying table shows you the relationship between stops and the "times increase." Here's an example.

You want to make a shot at $f/8$, but your flash unit calls for $f/4$ at the distance you are using it from the subject. The difference between f/8 and f/4 is two stops, which is a four times (4×) light factor. So, fire the flash four times, aimed at the same area from the same position. Be sure to let the unit recycle completely each time so that each flash will give you full light output. Obviously, this technique is useful only with stationary subjects. Anything moving through the area will be underlighted.

LIGHT INCREASE FACTORS

Number of stops light increase desired	Fire flash this many times
1	2
2	4
3	8
4	16
5	32

Getting a proper exposure setting in candlelighted scenes can be tricky. Bring the camera (or handheld meter) close to the subject, so the flame is not in its field of view, and take your light reading. Photo: K. Bancroft.

More Ideas for Night Photography

Many special-effect filters and lens attachments are especially useful with night subjects because the dark surroundings let the effect stand out clearly in the picture. For example, the repeat images produced by a multiple-image prism are clearer because there is no lighted background blending them together. Star screens work well because there are likely to be many bright point sources of light in the scene—steetlights, headlights, etc. Here are some other ideas for taking night pictures.

Small Flames. To get very local fill light, use a match, candle, or cigarette lighter. In a close shot, have the subject pretend to be lighting a cigarette, or using a match or candle to see something in the darkness. In a color picture, the warmth of this kind of fill light can be quite pleasing.

Flashlight Focus. It is often difficult to focus precisely under very dim light conditions. If you carry a small pencil flashlight, turn it on and place it at the subject position. You can focus on the bright point of its light quite easily. Have your subject turn it off, or remove it from the scene, before you take the picture.

Photograph Invisibly. You can photograph unseen in complete darkness by infrared. To do so, you do not need a lens filter, but the light source must emit only infrared. The best method is to cover an

electronic flash unit with a No. 87 or 87C filter. There will be no visible light, although a slight red glow may be visible to a subject looking directly at the flash unit. Load the camera with either color or black-and-white infrared-sensitive film. You will have to prefocus for a given distance zone, because you won't be able to see anything when you take the picture. Follow the exposure recommendations given in the film instruction sheet.

Sandwich. Some slides, especially those that are underexposed, produce night-like effects when combined. Try various combinations by overlapping slides on an illuminator. When you get a pair that work well together, remove them from their mounts and sandwich them together in a single mount. You'll get the sharpest results if you can combine them emulsion-to-emulsion. You can also sandwich a piece of blue gelatin filter with a slide to give a night effect. This works well with some water and snow scenes.

Including an available light source can add to your picture's mood as well as being a handy technique. Try to find one that blends in with your location. Photo: J. Richards.

Day for Night for Day

There may be times when you have a great idea for a night picture, but the things you need in the scene are only there in the daytime. For example, you may want some cars on the street, some passersby, and visual evidence that shops are open. Or, your props and model for a night-effect illustration may only be available during the day. Whatever the situation, you can fake it very convincingly by shooting day for night. That is, actually take the picture in daylight, but manipulate things so the results look like a night shot.

The opposite is also possible: Shoot at night, but make the results look like daytime. You might want deserted, full-light effect in a location that is actually crowded and busy during the day. So, shoot night for day. The possibilities are somewhat more limited than day for night, but it can be effective.

Day for Night. The basic technique for making a day shot look like night is quite simple. Work with the camera facing the sun, so your subjects are strongly backlighted; then underexpose for a silhouette effect. It will take some experimentation to get it right, but the illusion can be quite convincing.

In color night for day work, use a slow speed film, and take an exposure reading from the bright, open sky—not from the subject, and definitely not from the sun. In fact, be sure the sun is not in the shot, and use a deep lens shade to prevent flare that would weaken the effect or reveal the trick. To increase a sense of moonlight, use a blue filter over the lens.

Reduce exposure from the bright sky reading. If you reach the smallest lens aperture and need to reduce exposure even more, or if you want to use a particular aperture for depth of field control, you can use neutral density (ND) filters to cut down the light. These are grayish filters that absorb light but do not change the color balance. You can get them at photo stores in different densities to affect light as shown in the table. ND filters can be combined to produce greater effects. For

LIGHT CONTROL WITH NEUTRAL DENSITY FILTERS

Filter Strength*	Reduces Light by
0.3ND	1 stop
0.6ND	2 stops
0.9ND	3 stops

*Intermediate and greater strengths are available. Each 0.1 density increase reduces the light by one-third of a stop.

example a 0.3ND filter plus a 0.9ND filter has a combined effect of 1.2 density, or four stops light reduction. You can also combine an ND filter with a colored filtered to control light intensity as well as color.

To shoot night for day in black-and-white, use a medium red filter. Base exposure on a reading without the filter in place, then do *not* compensate for the light the filter absorbs.

If you need to have your subject visible, rather than silhouetted, in an apparent nighttime situation, use a flash unit at the camera. Keep the subject away from the background so the flash illuminates only him or her, without spilling revealingly onto the surroundings. Test shots with an instant-print camera are a big help in establishing exposure and light balance, either in black-and-white or in color.

Night for Day. There is no special filter or device to make night scenes look like daylight. Simply give very long exposures so the film can build up the same amount of density in each area that it would in a day exposure. With an ISO/ASA 125 film, start at f/5.6 for 15–25 seconds. The effect works best with evenly lighted areas, but be sure no night-only light sources such as street lights are included to give away the actual situation. Night for day pictures are not difficult in black-and-white, but there may be strange color shifts with color films because of the reciprocity effect (see Chapter 6).

Index

Black-and-white films, special, 74-75
 chromogenic films, 74
 infrared film, 74
Bright sunlight, exposure in, 29

Camera supports, Other, 80-81
Carnivals, fairs, and amusement parks,
 100-101
Cityscapes and buildings, 94-95
 Color and time of day, 22-23
 unbalanced, 71
Color films, special, 70
 duplicating films, 70
 infrared color film, 70
 micrographic film, 70
Color temperature and color balance, 63

Day for night, 118-119
Diffusing light, 58

Exposure, 26-37
 determining, 37
 effective, 34-35
 estimating, 28-29
 measuring, 30-33
Exposure at night, determining, 84

Fill-in flash, 60-61
Filters for color control, 62-63
 color conversion filters, 62
 light balancing filters, 63
Filters with natural light, 50-51
 black-and-white, 50-51
 color, 51
Full-moonlight scenes, exposure guide
 for, 105

Handholding long exposure, 81
High contrast black-and-white, 72-73
High-key and low-key effects, 48-49

Intensity and quality of light, 18-19

Light, characteristics of, 12-25
Light and color, 20-21
 color temperature, 20-21
Light and form, 24-25
Light direction and angle, 14-15
 daylight, 14-15
Light direction and definition of form, 25
Lighting, types of, 40-47
 backlighting, 44-45
 frontlighting, 40
 sidelighting, 42-43
 toplighting, 46
Light interiors, 96-97
Light qualities at night, 16
Long exposure, 86-87
 correct exposure, 86-87
 shutter settings, 86

Meter(s), 30-33
 incident light, 31
 reflected-light, 30-31
 spot, 32-22
Meter readings, interpreting, 36-37
Moonlight, 104-105
Moon pictures, 110-111

Natural Light, 54-63
Neutral density filters, light control with,
 118
Night effects, special, 106-119
Night exposure recommendations, 93
Night flash, 102-103
Night for day, 119
Night lights and subjects, 90-105
Night photography, 76-89
 films for, 82-83
 more ideas for, 116-117
Night sport events, 98-99
 exposure, 99
 lenses, 98-99
Nighttime color film, 83

Open shade and mixed light, 66-67
Overcast and bad weather lighting, 68-69

Painting with light, 114-115
Processing, special, 88-89
 pushing film, 88
 push processing, 88-89
 subjects and films for pushing, 88
Protecting your camera, 69

Reflecting light, 56
 natural reflectors, 56
 umbrella reflectors, 56
Reflectors, making, 57

Sidelighting, exposure for, 43
Sky shooting, 108-109
 aurora borealis, 109
 fireworks, 109
 lightning, 109
 star trails, 108-109
Softening light, 19
Soft light and special films, 64-75
Street scenes at night, 92-93
Sunlight, direct, 38
Sunrise and sunset, 52-53

Telephoto lenses, handholding, 98
Time, movement, and multiple exposures,
 112-113
Tripods and unipods, 78-79

Window light, boosting, 59

DATE DUE

SEP 0 6 2002

PRINTED IN U.S.A.

GAYLORD